RESCUE DOGS

Portraits and Stories

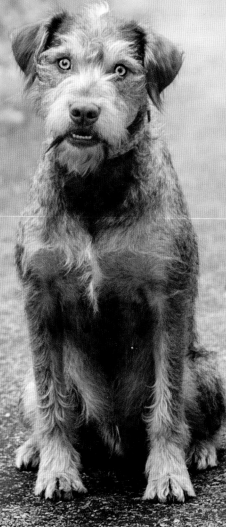

SUSANNAH MAYNARD

Amherst Media, Inc. ■ Buffalo, NY

Dedication

To all the dogs in my life—past, present, and future—but especially to Mr. Bojangles for inspiring me to discover my calling and for being my ever-patient muse.

Published by:
Amherst Media, Inc.
PO BOX 538
Buffalo, NY 14213
www.AmherstMedia.com

Publisher: Craig Alesse
Senior Editor/Production Manager: Michelle Perkins
Editors: Barbara A. Lynch-Johnt, Beth Alesse
Acquisitions Editor: Harvey Goldstein
Associate Publisher: Kate Neaverth
Editorial Assistance from: Carey A. Miller, Roy Bakos, Jen Sexton-Riley, Rebecca Rudell
Business Manager: Adam Richards

ISBN-13: 978-1-68203-298-5
Library of Congress Control Number: 2017940732
Printed in the United States of America
10 9 8 7 6 5 4 3 2 1

CONTENTS

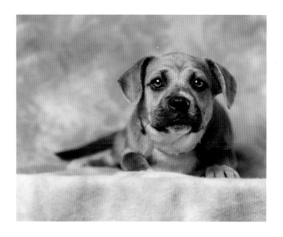

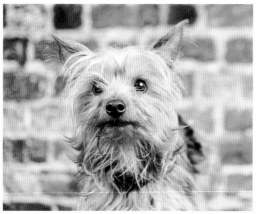

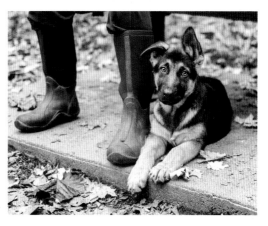

INTRODUCTION

As a lifelong animal lover I know that, unfortunately, not every animal has a home. That's why I want to give back to animals in need by using my talents to help them find that home. Photographing rescue pets is an important step in helping them get seen by as many potential adopters as possible. Studies show that pets with an adoption photo are more likely to get adopted than those without. Those same studies also show that the better the photographs and the friendlier the setting is for those images, the less time the dogs will spend waiting to find the right home. That's why this book, and the pro bono work I do for shelter and rescue pets, is so important.

That is also why an organization like HeARTs Speak exists. HeARTs Speak is a global community of more than 600 artists helping to increase the visibility of shelter animals around the world. As the saying goes, you never get a second chance to make a first impression, and that is what I and the other members of HeARTs Speak are dedicated to—giving shelter and rescue pets the best first impression possible. Nothing is more satisfying than to hear someone chose to adopt a particular dog because they saw your picture of them.

While the majority of the dogs in this book have already been adopted or were already adopted at the time I photographed them, it is still extremely important to raise awareness that rescue dogs make excellent pets. You can also see from this book that rescue dogs come in a variety of sizes, ages, and breeds—even purebred dogs can be found in shelters and rescues across the country and, in fact, around the world. According to the American Society for the Prevention of Cruelty to Animals (ASPCA), over 6.5 million companion animals enter shelters every year; many do not make it out alive. The ASPCA estimates that around 1.5 million shelter animals are euthanized every year. *That* is why this book and what I (and others like me) do is so important.

In this book, you will see a variety of dog images. Dogs photographed outside. Dogs photographed in a studio setting. Dogs photographed in the home. Puppies. Seniors. Dogs with special needs. My goal in sharing these images is to show you as much cuteness and personality as possible from very brief sessions of time with each dog. Some days I would photograph dozens of pets coming in on their freedom rides, and other days it would be a single dog or a litter of puppies at a foster parent's home.

I hope that in reading this book you will see that rescue dogs are good dogs that will make great members of your family. If you are looking to add a dog to your family, please consider a dog from a shelter or rescue. If you can't adopt a dog at this time, consider fostering one. If you can't foster,

then consider volunteering your time to help a rescue or shelter. If you can't adopt, foster, or volunteer, then consider donating to a rescue or shelter, as they will appreciate any small amount you can give, whether it be money or time. Just like with anything, however, I highly recommend you do your due diligence in choosing an organization to adopt from or support with your efforts. There are many resources available to research animal welfare organizations, such as GuideStar.org, GreatNonprofits.org, and CharityNavigator.org. Read reviews of the organizations. Talk to people in your community who are familiar with them.

Just as with anything else, not all groups are created equal, and some groups are better than others.

Besides giving back to animals in need with my photography, I am also giving back with this book by donating a portion of the proceeds to the following organizations: Recycled Doggies in Cincinnati, Muttville Senior Dog Rescue in San Francisco, and HeARTs Speak.

About the Author

Susannah Maynard is a lifelong animal lover, animal rescue advocate, and pet photographer. Long before she picked up her first camera—her mother's childhood Kodak Brownie—she captured images of the world around her with a pad of paper and a box of crayons. From her early childhood, Susannah was surrounded by a house full of cats, beginning her lifelong love of animals.

After trying a variety of careers, from fundraising to publishing, Susannah was

Photo © Jason Kenney.

at a career crossroads when, in 2011, she adopted her heart dog, Mr. Bojangles, and discovered there was such a profession as pet photographer. Deciding to turn her love of both photography and pets into a career, Pet Love Photography was born.

Susannah has spent the last several years honing her skills as a pet photographer by photographing hundreds of rescue and client pets. She primarily works on location to make sure that her pet subjects are as comfortable as possible in environments that are familiar to them. She is a member of HeARTs Speak and Professional Photographers of America.

When not out photographing other people's pets or donating her time to rescue organizations or other pet charities, Susannah spends time with her own pet family of rescue dogs, Stella, Mr. Bojangles, and Paco, as well as her rescue cat, Diana.

1 PUPPIES

Chip

Chip and his sister, Joanna, were pulled from a rural Ohio kill shelter when they were eight weeks old. In rural areas, puppies are often surrendered to the shelter, while the mom dog is not. While Chip was billed as a St. Bernard and Labrador Retriever mix by the rescue, the shelter said the mom was a small Beagle. A lot of times the rescue guesses breeds based on looks; sometimes they know, but most of the time they don't.

Chip and Joanna were adopted into separate homes in January 2016.

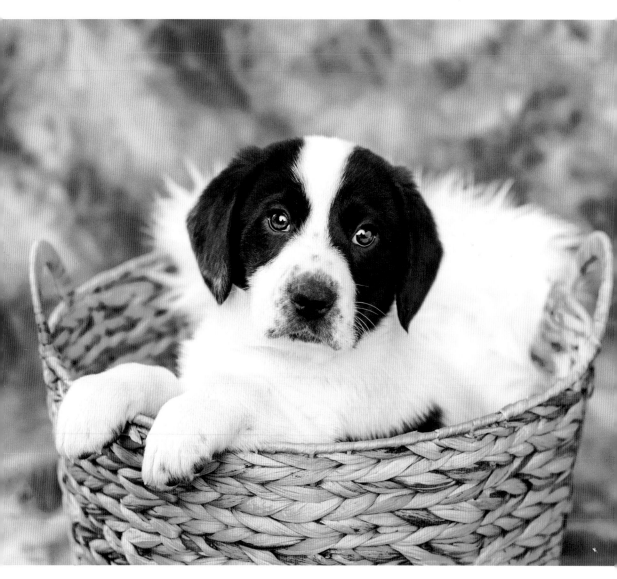

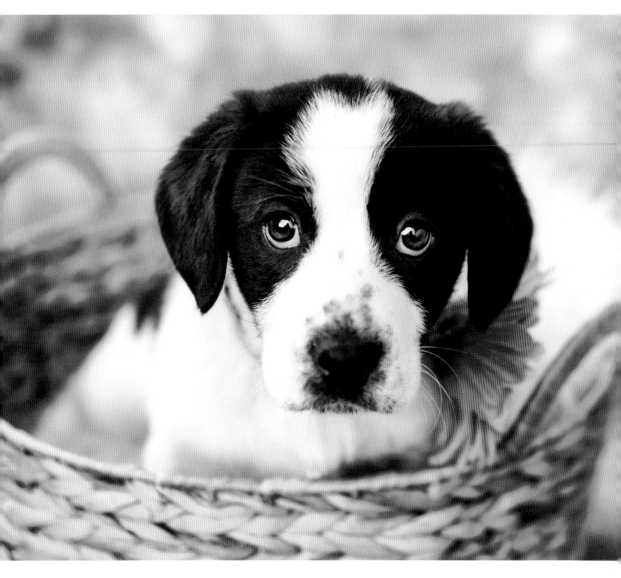

Joanna

Joanna's adopters named her Kaia. They also had a DNA test done, which determined that she was a Beagle (the shelter was correct) and Border Collie mix! Kaia and Chip (now Roman) are both happy and loved in their respective new homes.

" Kaia and Chip (now Roman) are both happy and loved in their respective new homes. "

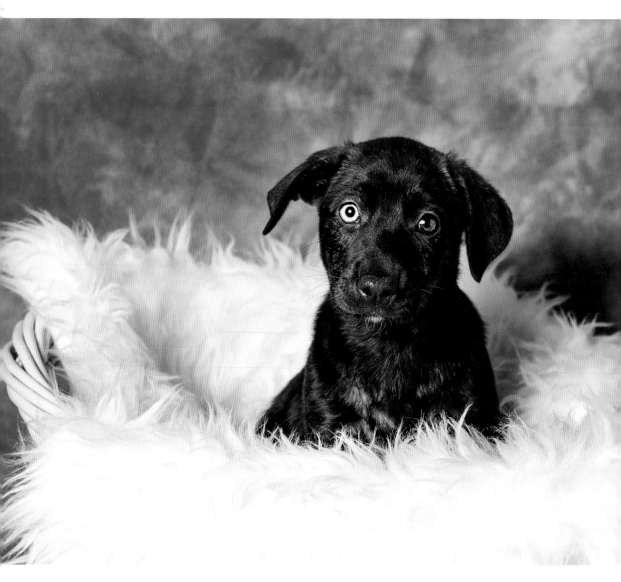

Jana

Jana and J-Lo, along with their brothers Jamie and Jasper (and their mom, Ninner) were rescued from a rural Ohio county shelter. They spent some time in the pound while their owner was investigated for cruelty, before making their way into rescue.

Jana, an eight-week-old German Shepherd and Labrador Retriever mix, was unique amongst her siblings with her brindle coat and light-colored eyes.

Jana was adopted in January 2016.

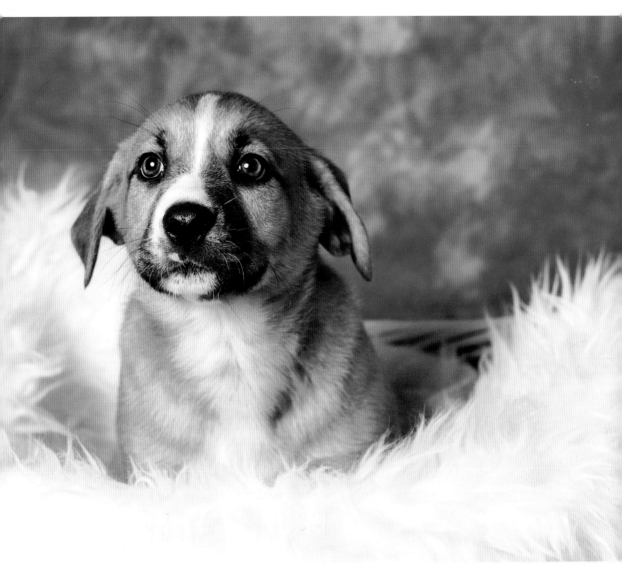

J-Lo

J-Lo, an eight-week-old German Shepherd and Boxer mix, was the only one to have the tan and white coloring. Her brothers Jasper and Jamie were solid black like their mother, Ninner, a German Shepherd mix.

J-Lo was adopted in January 2016.

66 J-Lo, an eight-week-old German Shepherd and Boxer mix, was the only one to have the tan and white coloring. 99

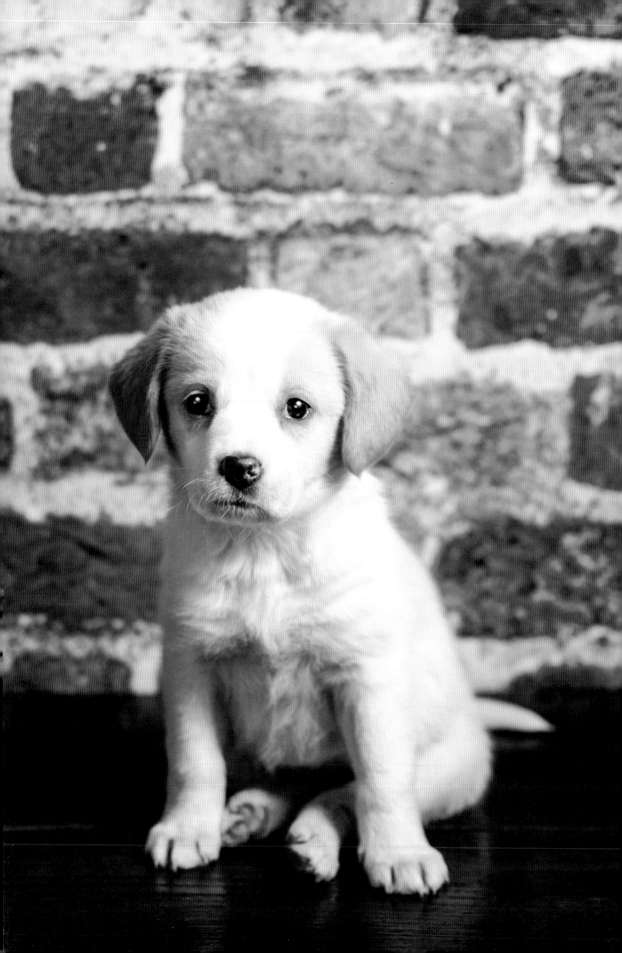

Adele

(previous page and below) Adorable Adele, a two-month-old Golden Retriever and Beagle mix, came from a rural shelter with her three brothers and two sisters. This litter of puppies was named the "Rocker" litter. She was joined in rescue by her brothers Axl, Ozzy, and Slash, and her sisters Pink and Rose.

Adele and her siblings developed ringworm shortly after coming to the rescue and had to be quarantined during their medical treatment, so the pups spent some extra time in rescue before being adopted in July 2016. Part of their treatment included shaving their fur, so their "naked" bodies were slightly disguised in their updated adoption portraits.

Adele, at three months, definitely shows her Beagle heritage.

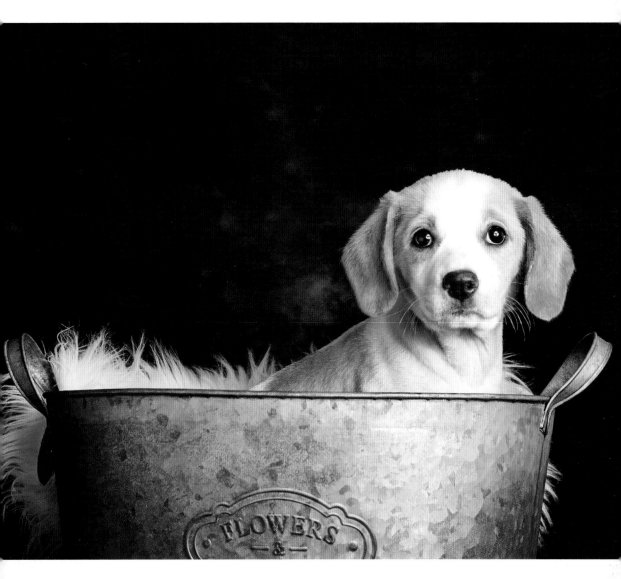

Charlotte

(below) Charlotte, an eight-week-old Shih Tzu and Terrier mix, was born into rescue along with her brothers Hugo, Joey, Willie, and Ziggy. Charlotte and her brother Joey are white with blue eyes, which can often signal deafness. Charlotte had a bit of a rough go in the adoption process, which is hard to believe for such a cute puppy, but after getting returned once, she finally found her forever home in April 2016.

Zuko

(following page) Zuko, a four-month-old Siberian Husky mix, somehow found himself in rescue. However, this energetic and playful puppy just activated his hypnotic blue gaze until his new family surrendered to his charms. He was adopted in March 2016.

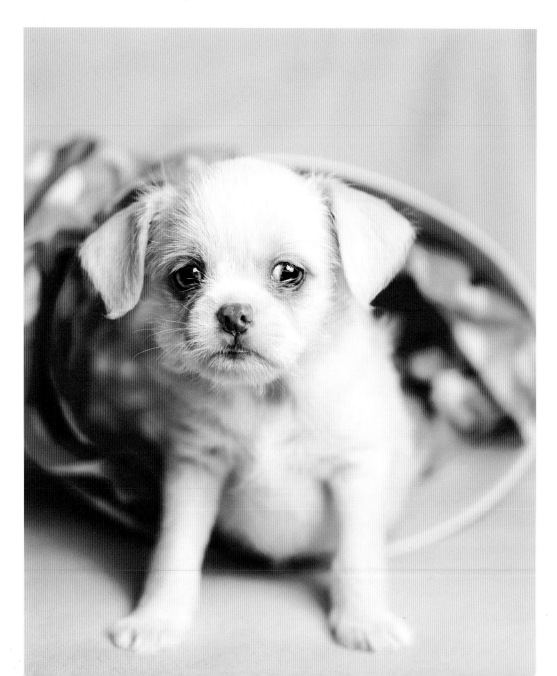

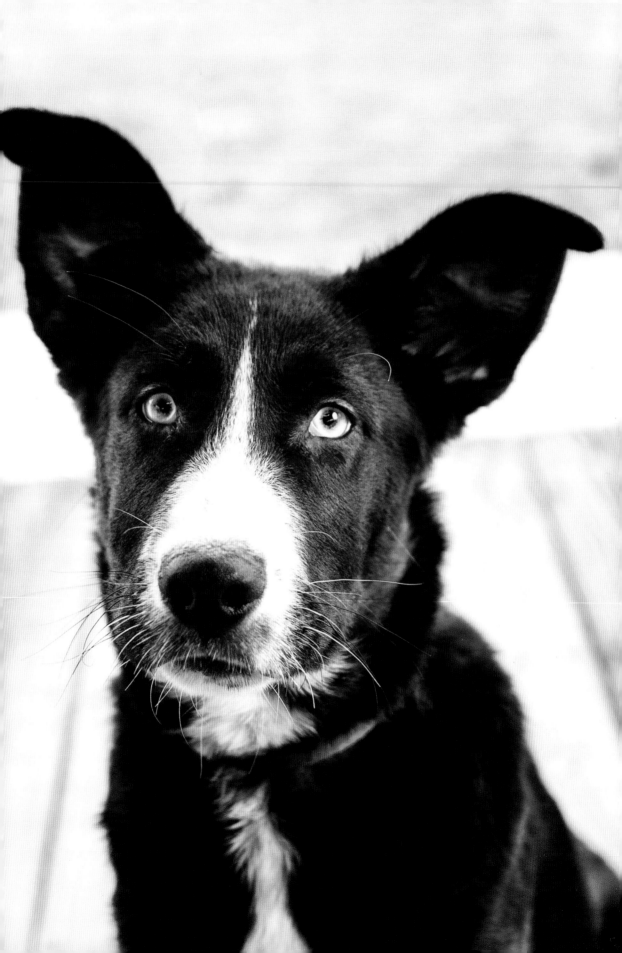

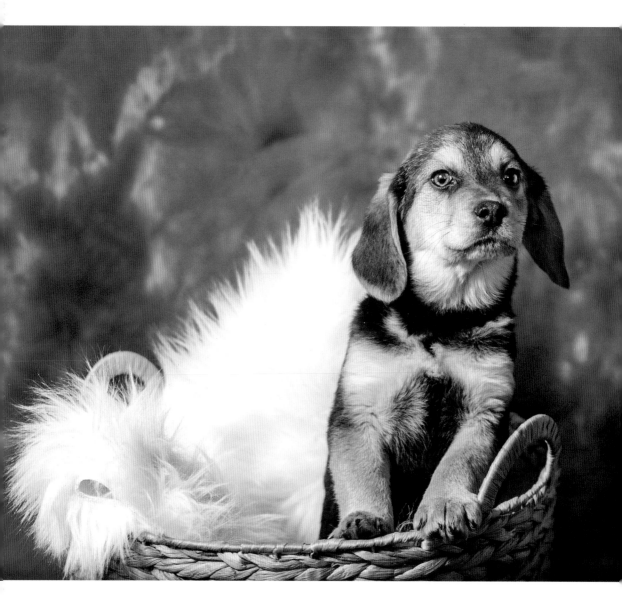

Bernadette

(above) Ten-week-old Bernadette, a Labrador Retriever and Beagle mix, came to rescue from a rural shelter along with the rest of her *Big Bang Theory* siblings: Howard, Leonard, Raj, Sheldon, and Stewart. Loving nothing more than to cuddle, she didn't have to look long before she found her forever home. She was adopted in May 2016.

Lightning

(following page) Lightning, a four-month-old Boxer mix puppy, was rescued from a rural high-kill shelter along with his brother, Thunder, and sister, Rigby. Lightning and his sister were adopted at their very first adoption event in March 2016.

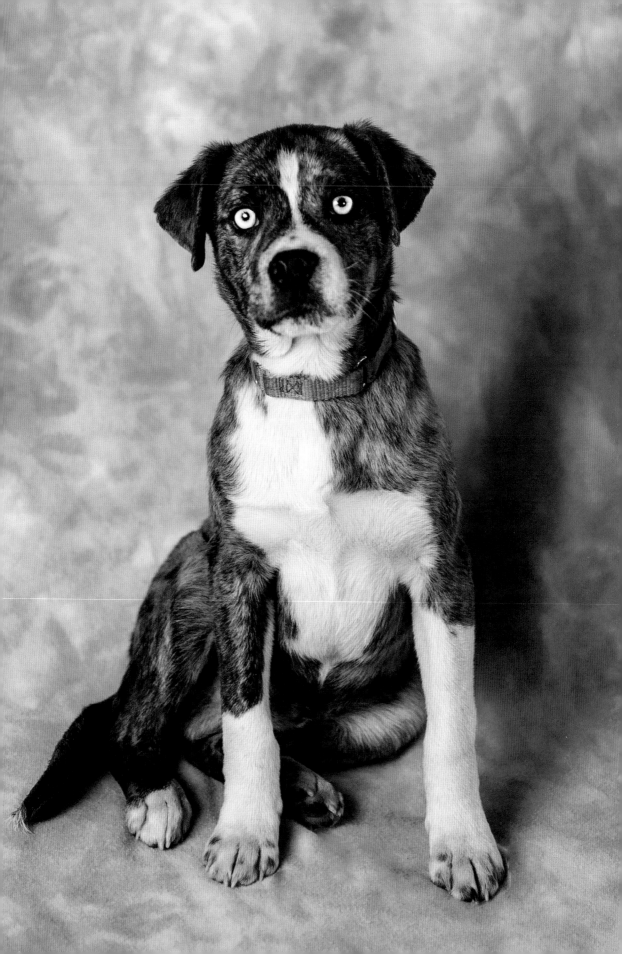

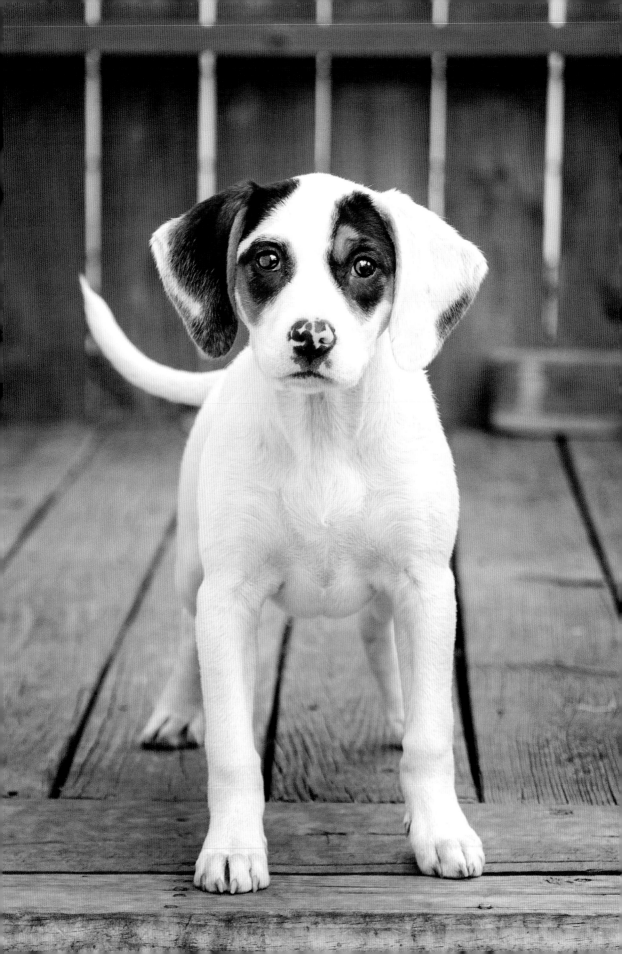

Ann

(previous page) Ann, a three-month-old English Coonhound mix, arrived in rescue from a rural shelter at three days old. She was accompanied by her mom and nine siblings. Prior to their adoption debut, the puppies fell ill and had to be separated into new foster homes. Sadly, one of the pups didn't make it, but Ann and her other siblings were adopted in April 2016.

April

(below) April, a three-month-old English Coonhound mix, and her sister, Ann, were part of the "Barks and Recreation" litter of ten puppies. Due to their illness, this litter of pups spent more time in foster care than puppies typically do before adoption.

April was adopted in April 2016.

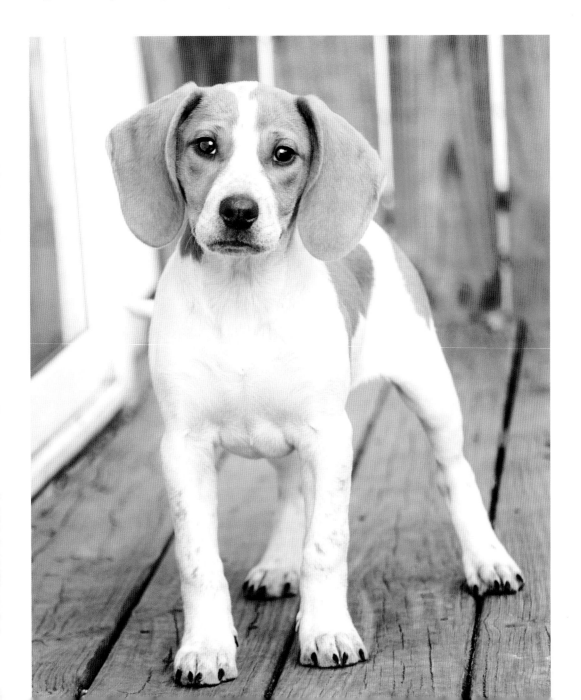

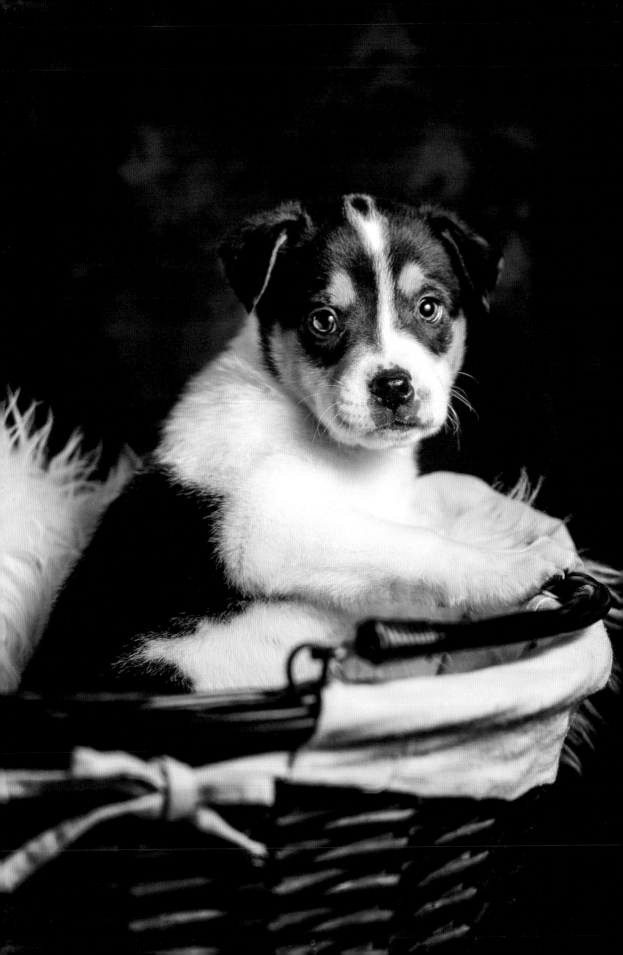

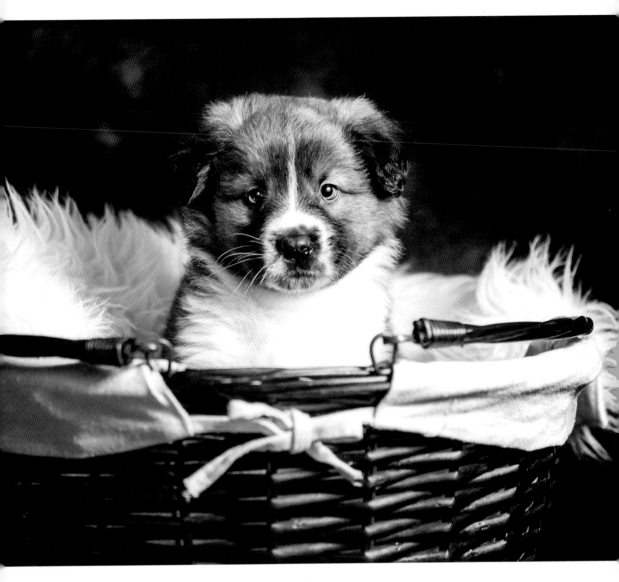

Poe

(*previous page*) Poe, a two-month-old Australian Shepherd and Boxer mix, was brought to rescue after she ended up in a rural kill shelter with her two brothers, Edgar and Allan. Leader of the pack Poe is an energetic puppy who was adopted in April 2016.

Edgar

(*above*) Fluffy eight-week-old puppy Edgar, an Australian Shepherd and Boxer mix, was rescued from a rural kill shelter along with his brother, Allan, and his sister, Poe. This sweet and fluffy guy loves to nap. He was adopted in April 2016.

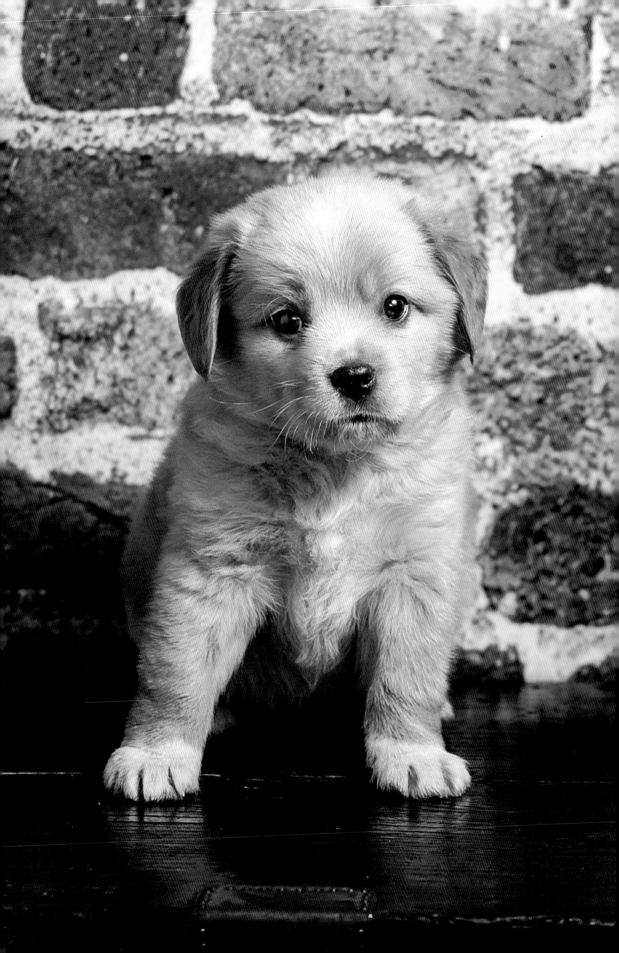

Ozzy

(previous page and below) Ozzy, a two-month-old Golden Retriever and Beagle mix, came from a rural shelter with his sisters Adele, Pink, and Rose, and his brothers Axl and Slash. This fluffy guy definitely looks the most like a Golden Retriever of all his brothers and sisters.

The entire "Rocker" litter had to stay a little longer than expected in their foster home after coming down with a case of ringworm. After many sulfur baths and some shaved fur, they all made their adoption debut about a month late. Ozzy and his adorable littermates were adopted in July 2016.

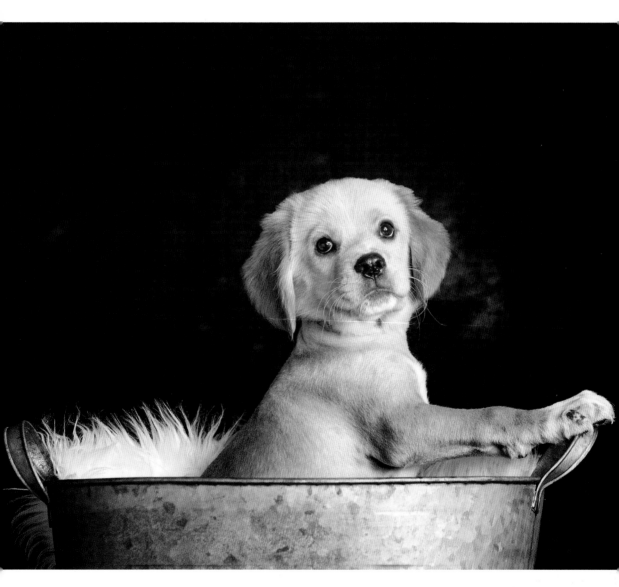

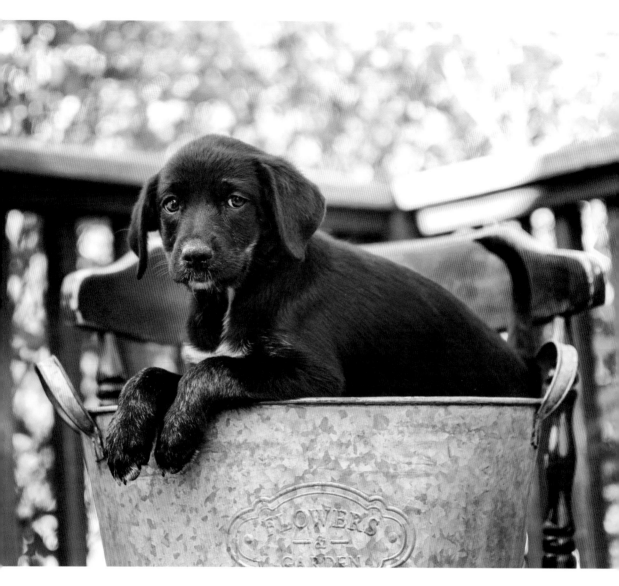

Meatlug

Meatlug, an eight-week-old German Shepherd and Labrador Retriever mix, was one of the *How to Train Your Dragon* litter.

Meatlug was joined in rescue by his siblings Astrid, Fishleg, Hiccup, Stormfly, and Toothless. He was adopted in June 2016.

Claire

Claire, an eight-month-old Plott Hound mix, came from a rural shelter where she was used as the test dog to see how dogs in the shelter behaved with other dogs. When she arrived in her foster home, she didn't want to eat. After much coaxing and comforting and trying out different foods, her foster parent finally got Claire to eat.

Claire spent three months in her foster home before being adopted into her loving new family in September 2016.

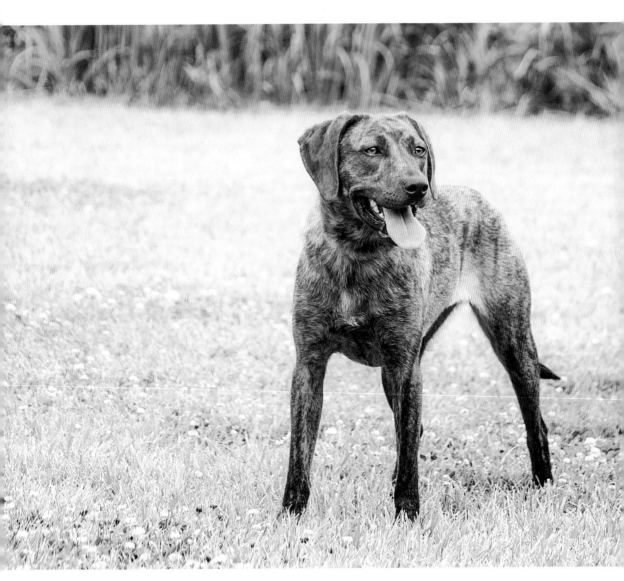

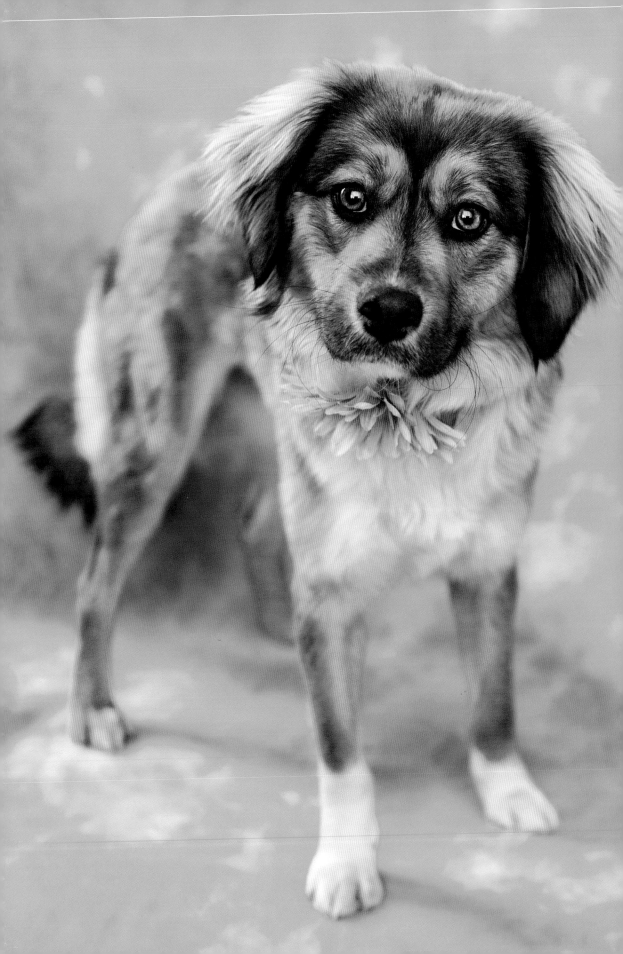

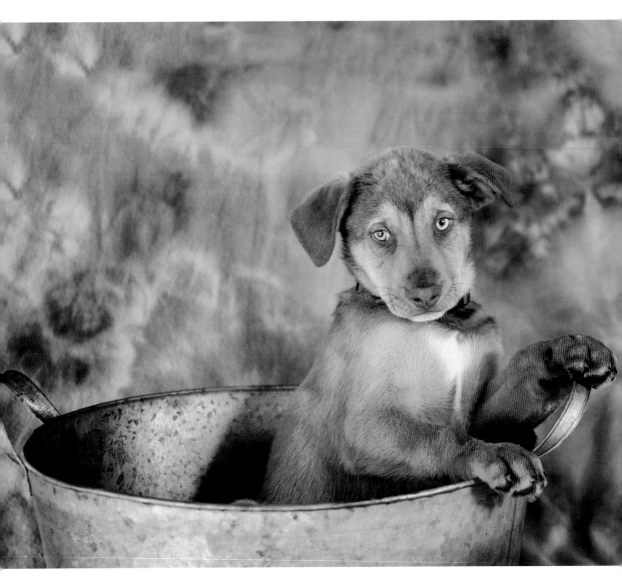

Socks

(previous page) Socks, a nine-month-old Australian Shepherd and Shetland Sheepdog mix, ended up in rescue as many energetic puppies often do. This playful, loving, and intelligent girl found her forever home in January 2016.

Ramsey

(above) Ramsey, a three-month-old Rhodesian Ridgeback mix, came to rescue from a rural kill shelter along with his two siblings. Ramsey, an outgoing and energetic puppy, was adopted in May 2016.

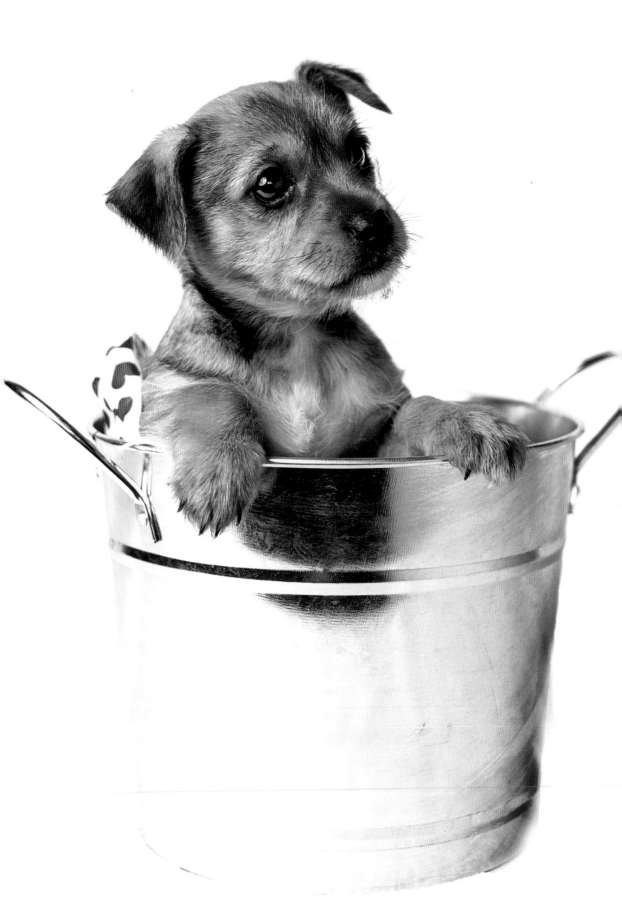

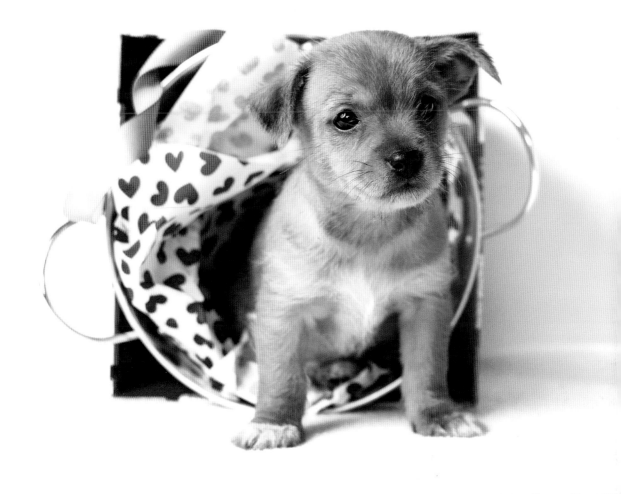

Hulk

(*previous page*) Adorable two-month-old Hulk and his brothers Batman, Ironman, and Superman were born into rescue. They are Chorkies—Chihuahua and Yorkshire Terrier mixes. Their mom, Dixie, is a Chihuahua, so it's a best guess on the dad based on their appearance. Hulk was so named because he was the biggest pup in the "Superhero" litter. He was adopted in February 2016.

Ironman

(*above*) Ironman, like his brothers Hulk, Batman, and Superman, was born into rescue. At two months old, these guys were all still super tiny, which is typical for both Chihuahuas and Yorkies, as these tend to be some of the smallest toy dogs. Like his brothers, Ironman was adopted in February 2016.

Lily

Lily, an energetic two-month-old Siberian Husky mix, was joined in rescue by her brother Sawyer. Lily loves playing with toys and was especially fond of taking toys from her brother's mouth. She was adopted in May 2016.

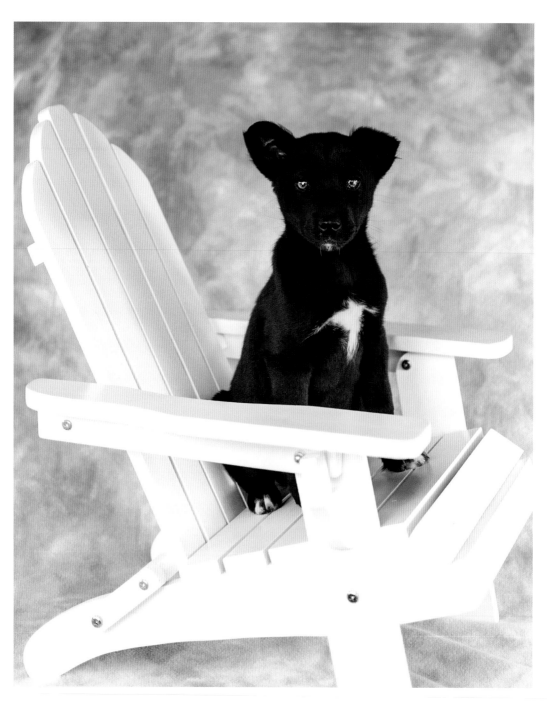

Sawyer

Sawyer, a two-month-old Siberian Husky mix, came to rescue with his sister, Lily, from a rural shelter. Sawyer loved playing with his sister, but was definitely the follower and not the leader. Both Sawyer and his sister were adopted into their forever homes in May 2016.

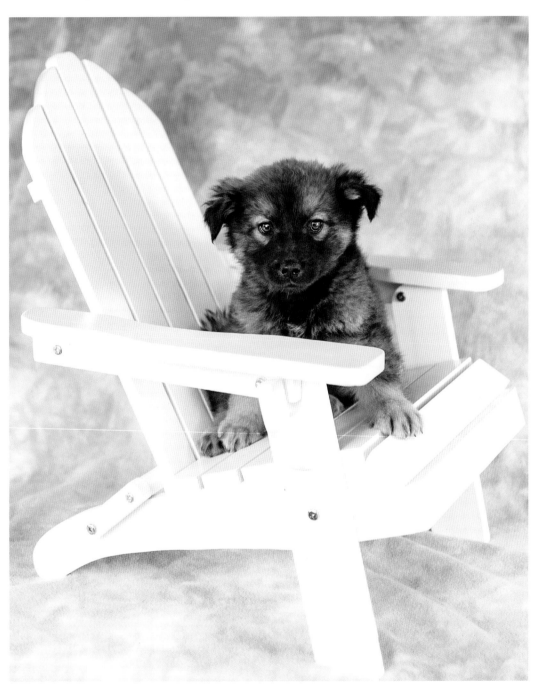

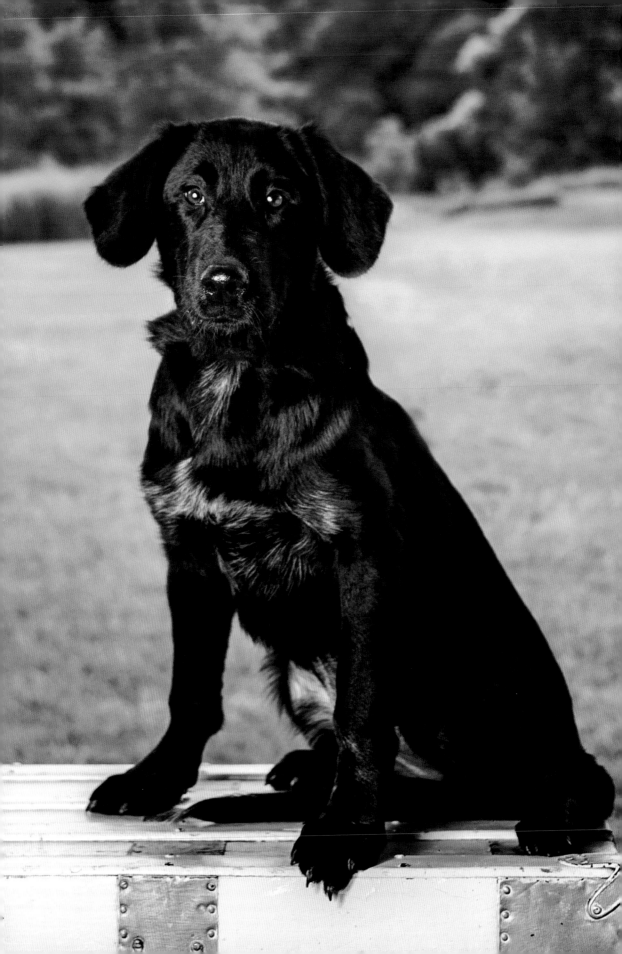

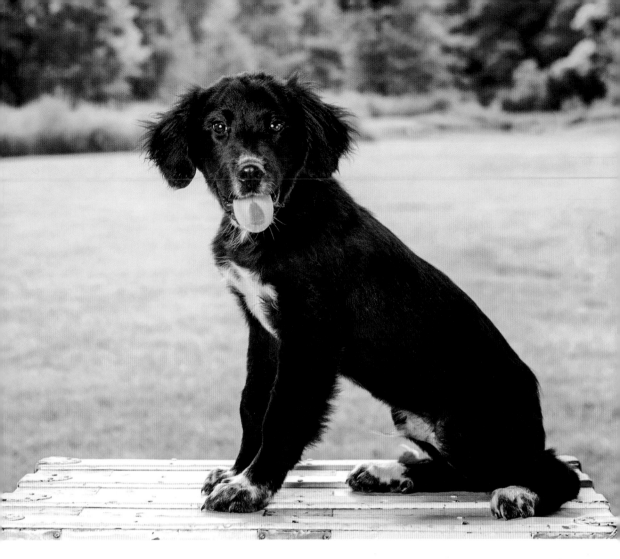

Riley

(*previous page*) Riley, a four-month-old Great Pyrenees and Labrador Retriever mix, came from a rural area where oftentimes puppies are bred and dumped at shelters when caring for them becomes too much work for the owners. Many times, the parents of dogs in rescue aren't known, but due to Riley's and his siblings' situation, it is known that his mom was a purebred Lab and his dad was a purebred Great Pyrenees. Riley and his siblings were all adopted at their first adoption event in July 2016.

Benji

(*above*) Benji, a sibling to Riley and a sister, Miley, is a Great Pyrenees and Labrador Retriever mix known to come from purebred parents. All three puppies were adopted in July 2016 at their debut adoption event.

" . . . oftentimes, puppies are bred and dumped at shelters . . . "

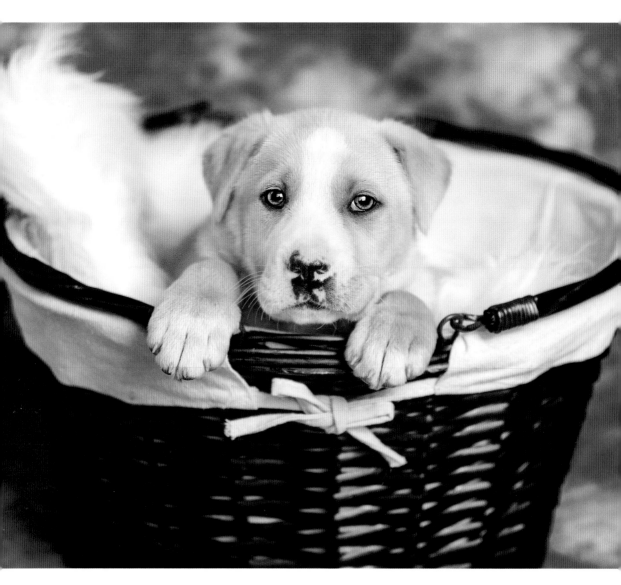

Cash

Cash and his sister, June, were rescued from a rural high-kill shelter. Cash, a two-month-old Shar Pei and Boxer mix, is a sweet dog who loves his chew rope and having a yard to play in. He found his own yard in April 2016.

66 Cash, a two-month-old Shar Pei and Boxer mix, is a sweet dog who loves his chew rope and having a yard to play in. 99

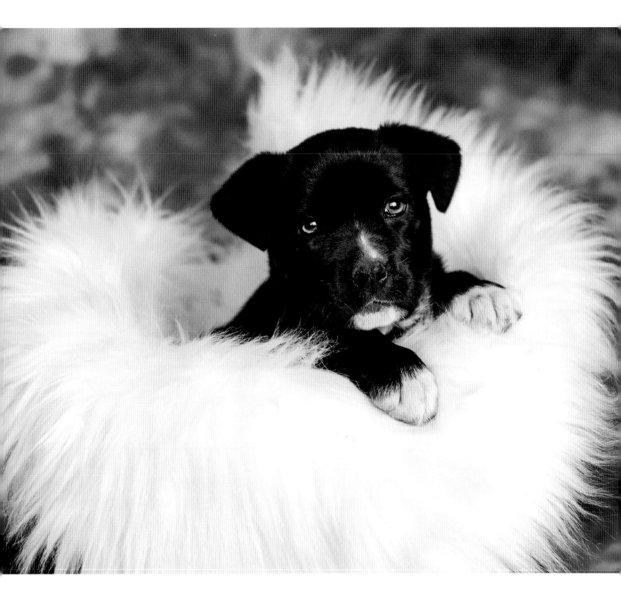

June

June, a two-month-old Shar Pei and Boxer mix, was brought into rescue from a rural shelter along with her brother, Cash. Showing how diverse puppy siblings can be, June's brother, Cash, is a light tan and white, while June's coat is predominantly deep black.

June was a little on the shy side, but that didn't stop her from finding her forever home in March 2016.

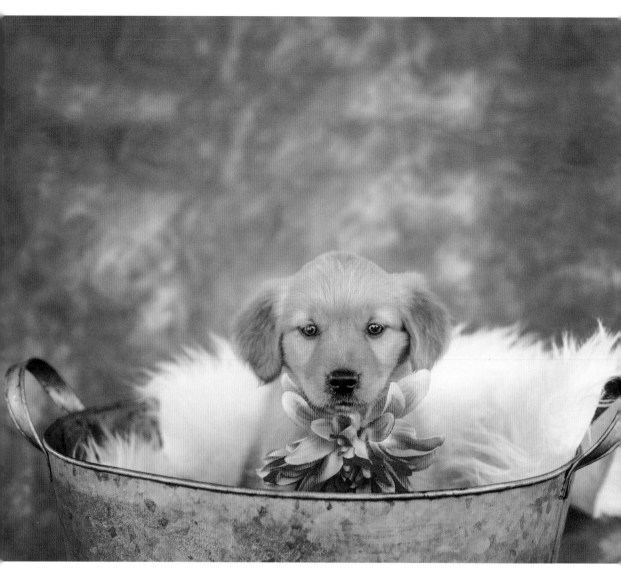

Astrid

Astrid is an eight-week-old German Shepherd and Labrador Retriever mix. She and her brothers and sisters were dubbed the *How to Train Your Dragon* litter. Oftentimes when there are litters of puppies, the fosters get to name them and will pick out a theme to make the naming fun.

Astrid was the only blonde in a family of black and brindle puppies. She was adopted in June 2016.

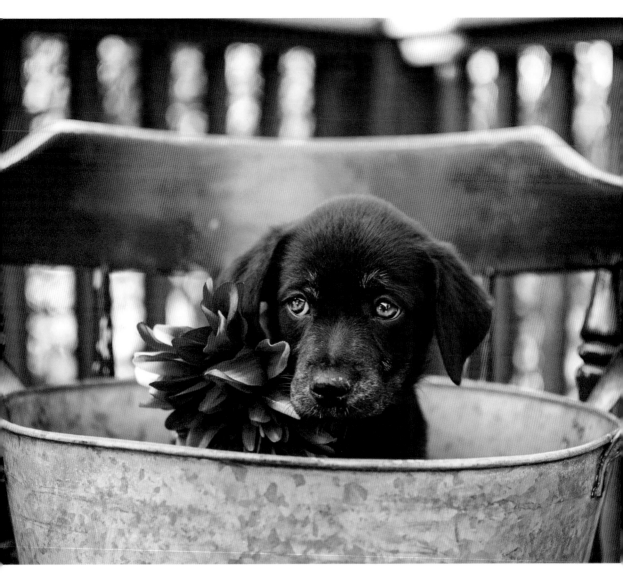

Stormfly

Stormfly, an eight-week-old German Shepherd and Labrador Retriever mix, was another member of the *How to Train Your Dragon* litter. Stormfly, along with her siblings, was adopted in June 2016.

❝ Stormfly, an eight-week-old German Shepherd and Labrador Retriever mix, was another member of the *How to Train Your Dragon* litter. ❞

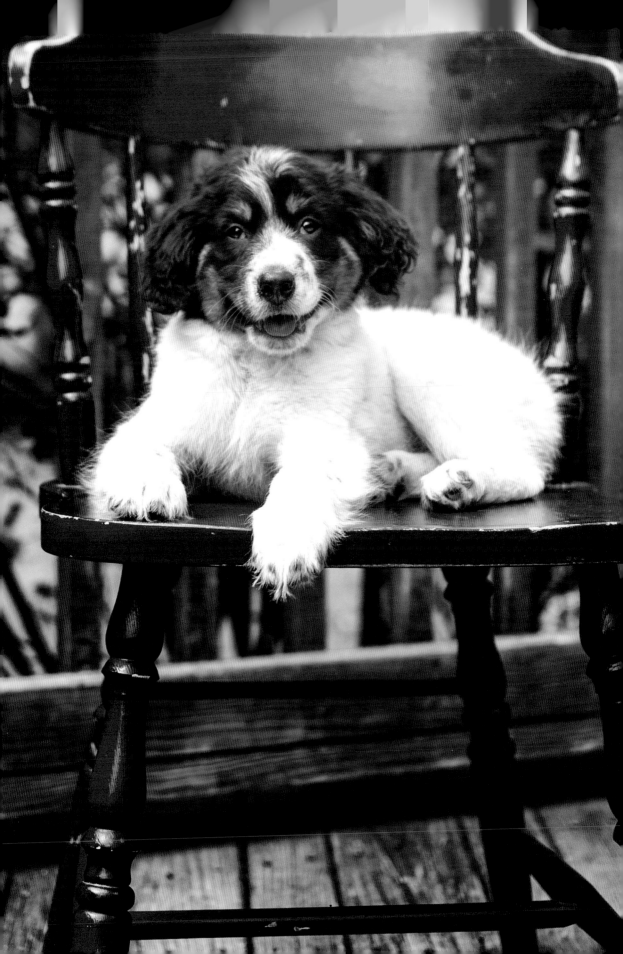

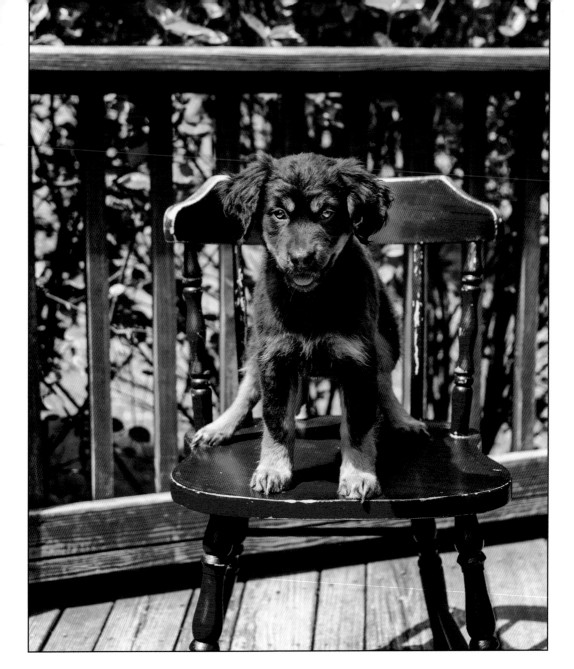

Emerson

(previous page) Emerson, a twelve-week-old Australian Shepherd mix, was part of a litter of six puppies rescued from a rural kill shelter. He is a playful pup that loves to play and wrestle with his siblings and run around outside. He was adopted in New York in June 2016.

Eden

(above) Eden, a twelve-week-old Australian Shepherd and Labrador Retriever mix, was part of a litter of six puppies rescued from a rural kill shelter. An inquisitive and active puppy, Eden was adopted in New York in June 2016.

Otter

(below) Otter, a ten-month-old Basset Hound, lived those first ten months of his life outdoors until he ended up with a rescue. Sadly, in rural areas, dogs—especially hounds of any kind—are left outdoors and frequently neglected. While still a baby, one of Otter's back legs was broken and his owner at the time didn't get it fixed, giving Otter a permanent limp. Fortunately, this sad start to life didn't deter Otter from being a friendly guy who loves to snuggle and give kisses. He was adopted in January 2016.

Taffy

(following page) Taffy, a nine-week-old Boxer and Pit Bull Terrier mix, ended up in rescue along with her brother Chaplin when the family that had them gave them up because Taffy had a leg injury they couldn't afford to care for. Sadly, this is something that happens all too often. Fortunately for the playful and fun-loving Taffy, she found her new home in no time flat. She was adopted at her first adoption event in March 2016.

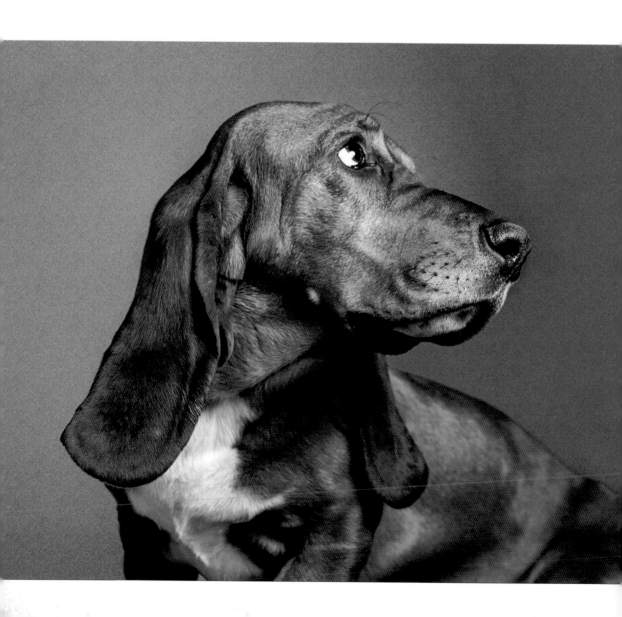

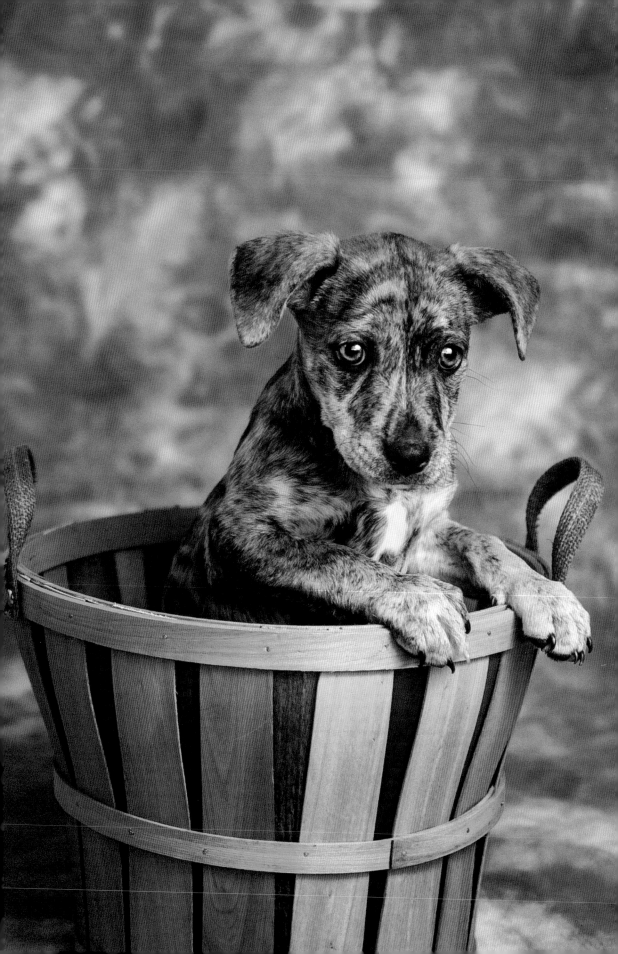

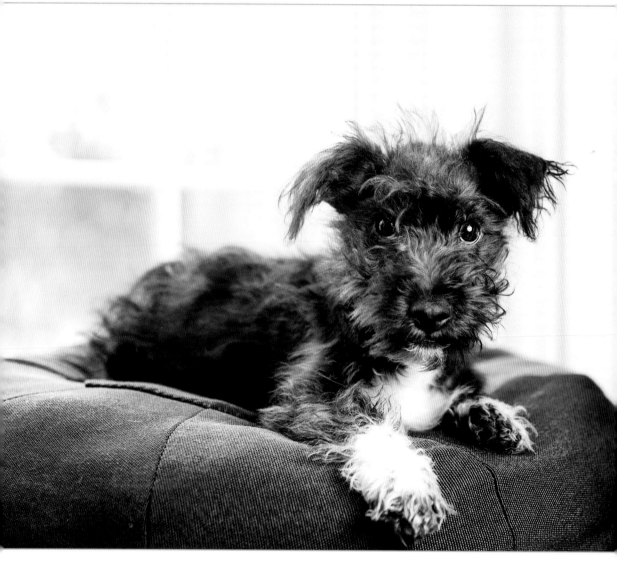

Wallace

Wallace, a four-month-old Scottish Terrier and Schnauzer mix, ended up in a rural Kentucky shelter. Fortunately, he was pulled by a rescue when a foster stepped up to take him in. This heartbreaker received more than twenty-five applications to adopt him. His lucky adoptive family took him home at his debut adoption event in January 2016.

66 This heartbreaker received more than twenty-five applications to adopt him. 99

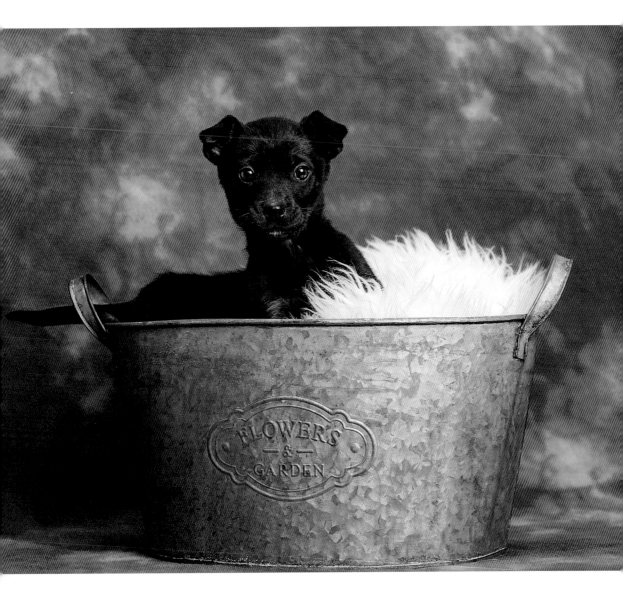

Peacock

Peacock, a Miniature Pinscher mix puppy, found herself at a shelter. Fortunately for this little black puppy, it was a no-kill shelter where she was able to win over the hearts of a new family all her own. She found her forever home in February 2017.

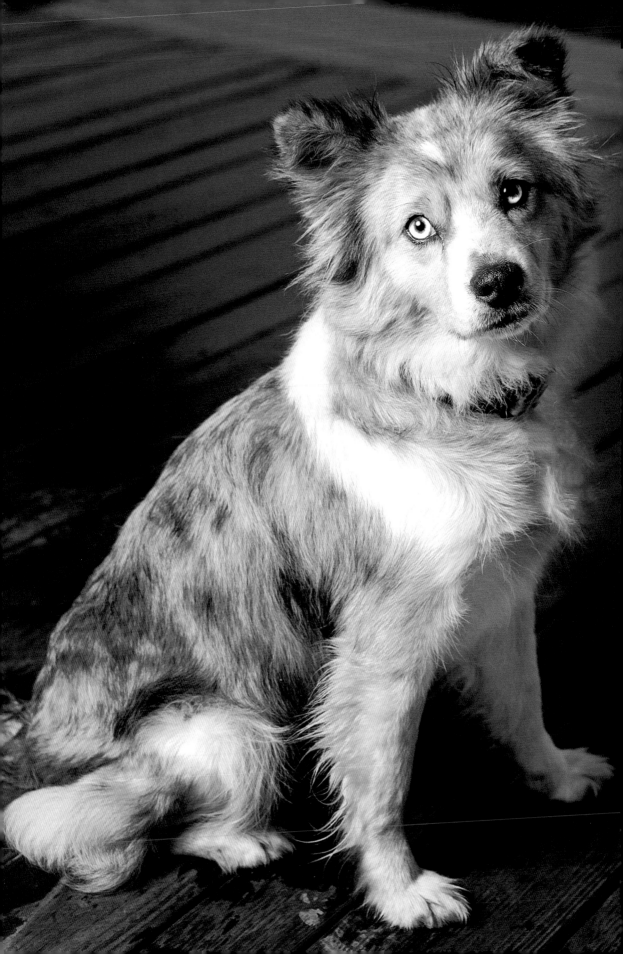

Ladybug

(previous page) Ladybug, an eight-month-old Mini Australian Shepherd and Sheltie mix, wondered how a gorgeous girl like her ended up in rescue. However, she didn't let that get her down, as she put her energy left over from playtime into hooking a new family with her beautiful blue eyes. She was adopted in March 2016.

Bruce

(below) Bruce, a five-month-old Doberman mix, is a smart and energetic puppy who survived parvo before coming to his foster family. He was adopted into a family with other big dogs and two human siblings.

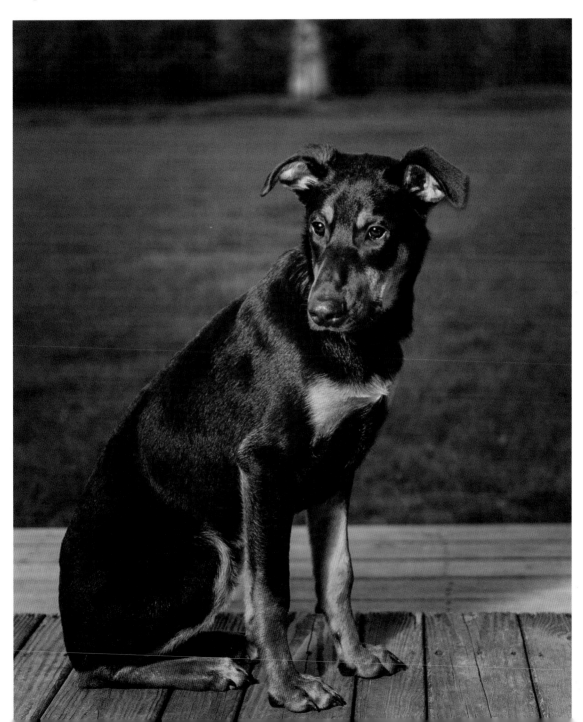

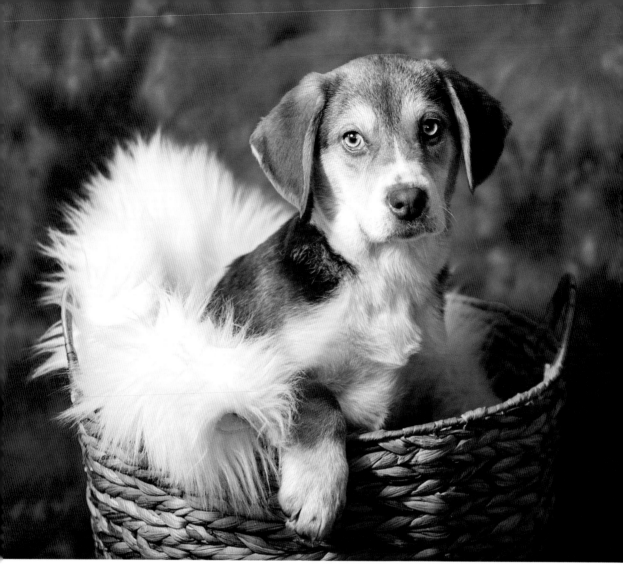

Sheldon

(above) Sheldon, a nine-week-old Labrador Retriever and Beagle mix, ended up in a rural kill shelter, but fortunately, a foster with a rescue stepped up to save him and his siblings. Sheldon, a rambunctious puppy, quickly won the hearts of a new family and was adopted in May 2016.

Charlie Brown

(following page) Charlie Brown, a Labrador Retriever mix, was born into rescue with his siblings Linus, Lucy, Sally, and Schroeder—the *Peanuts* litter. Time is of the essence when pulling pregnant dogs from shelters, as it's better for the puppies to be born in rescue than in a shelter due to the high probability of contracting a disease. Their mom was a Black Lab mix, and their dad's lineage was unknown. Charlie Brown was adopted in January 2016.

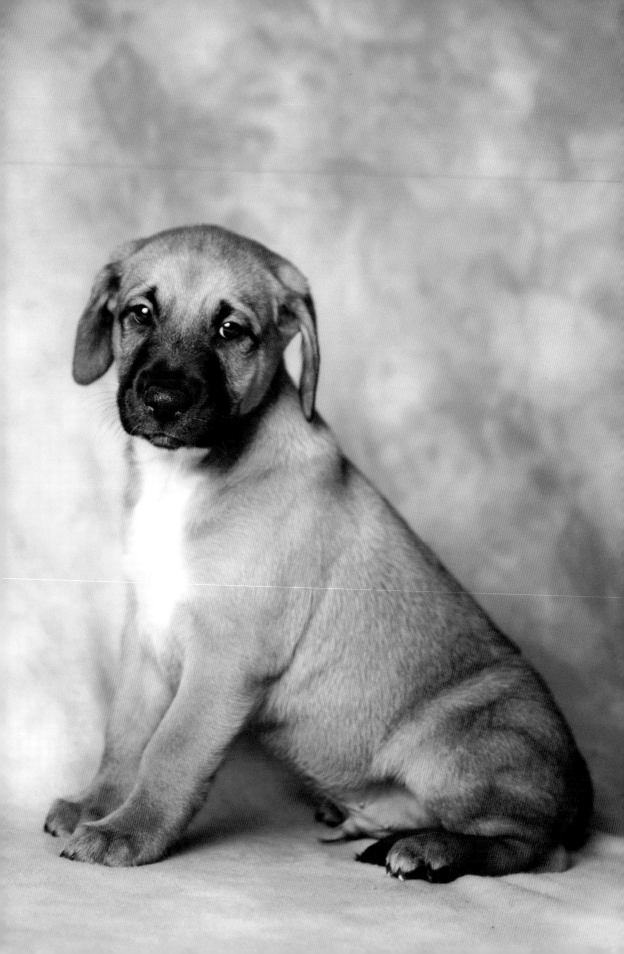

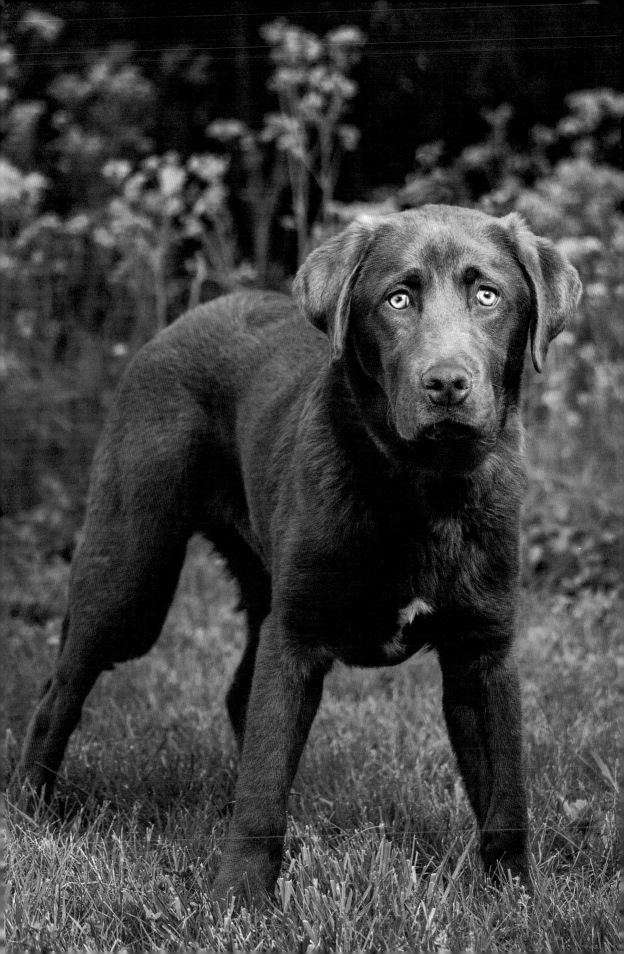

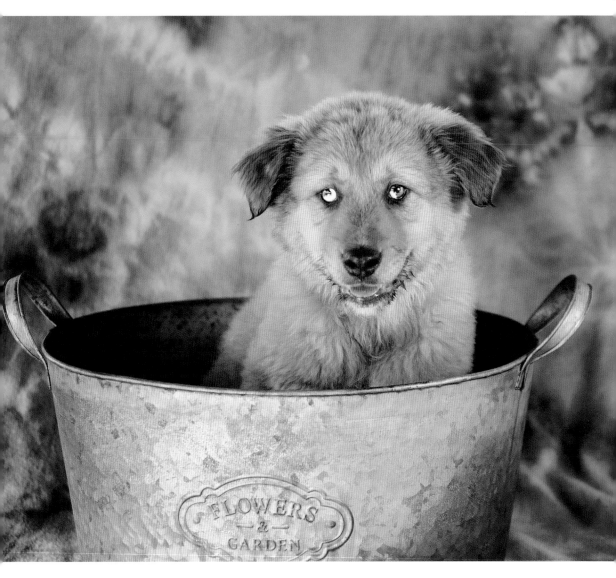

Moose

(*previous page*) Moose, a Labrador Retriever mix, definitely lived up to his name. At only six months old, he was quite a big dog.

Moose is a typical energetic and playful Lab. He was adopted in May 2016.

Renfro

(*above*) Renfro, a shy three-month-old Chow Chow mix, ended up at a rural kill shelter with his brother and sister. If puppies aren't moved out of shelters quickly, they face death, not just from being euthanized, but from disease. Fortunately, Renfro and his siblings were brought into rescue and adopted in May 2016.

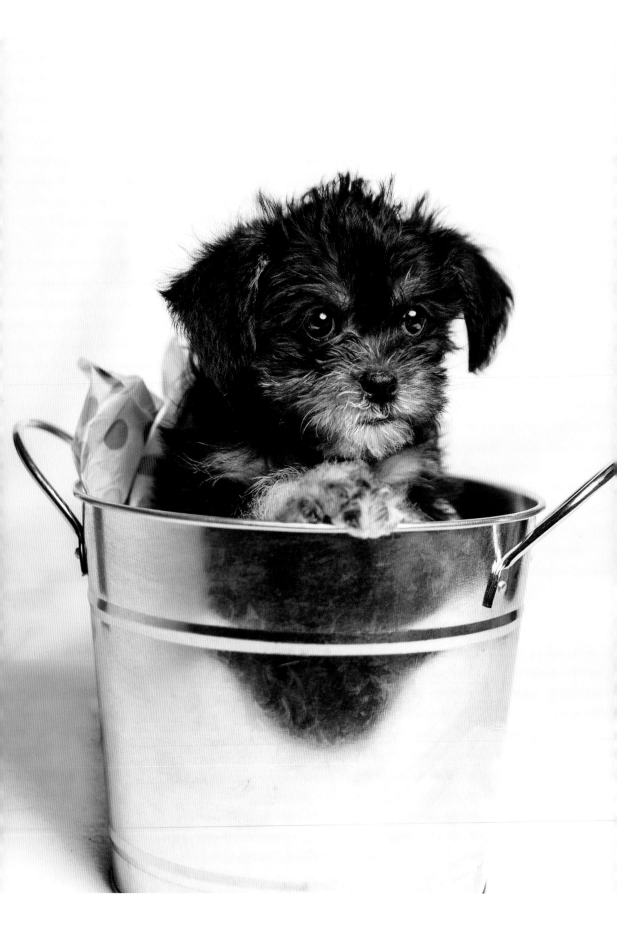

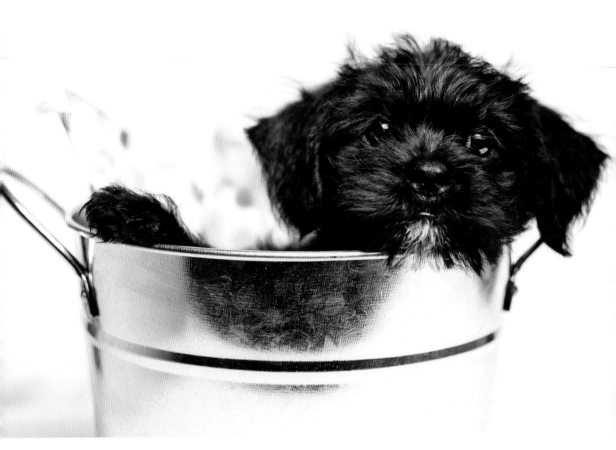

Hugo

(previous page) Scruffy little eight-week-old puppy Hugo, along with his brothers Ziggy, Willie, and Joey, and sister, Charlotte, were part of a litter born in foster care. Mom was a white Maltese, Terrier, and Shih Tzu mix, and dad's breed was unknown.

Hugo was the biggest of his litter. He was adopted by his foster family in March 2016, just as soon as it was "legal" with the rescue. His family simply couldn't bear to part with this adorable little guy.

Willie

(above) Adorable little Willie, an eight-week-old Shih Tzu and Terrier mix, was a heartbreaker from the start with his scruffy charm. He was born in foster care along with his siblings Charlotte, Joey, Hugo, and Ziggy.

Willie was adopted by a teenage rescue volunteer, because nothing can assuage a broken heart like snuggles from an adorable puppy. Willie enjoys being spoiled by his mom and giving all his love in return.

2 ADULT DOGS

Scarlet

(below) Scarlet, a three-and-a-half-year-old German Shepherd and Beagle mix, came to rescue with her puppies from a rural shelter. With her puppies all adopted into loving homes the previous month, Scarlet was ready to interview her own adopters. This attention-loving wanna-be lapdog found her new home in March 2016.

Patches

(following page) Patches, a five-year-old Australian Shepherd mix, ended up in rescue after her owner died and she was taken to the vet to be euthanized. Because Patches was young and healthy, the vet refused to put her down and contacted a rescue to take her and find her a new home. After spending a couple months in rescue, she was finally adopted in April 2016.

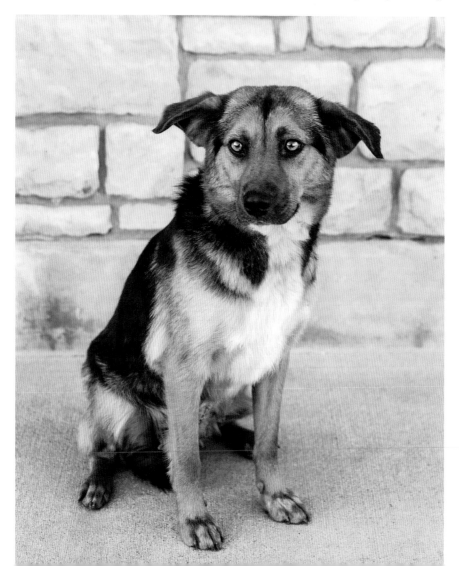

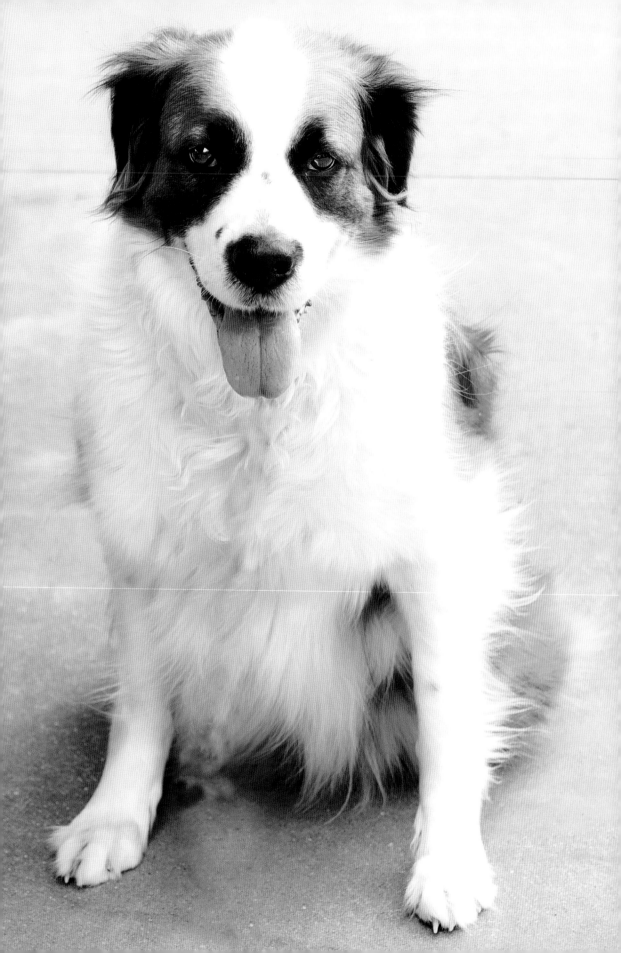

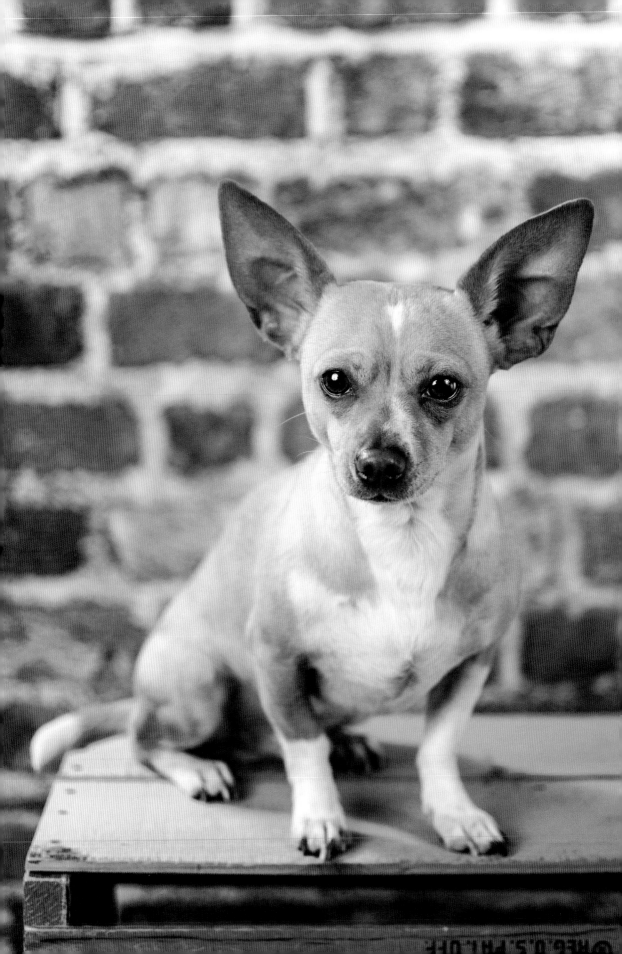

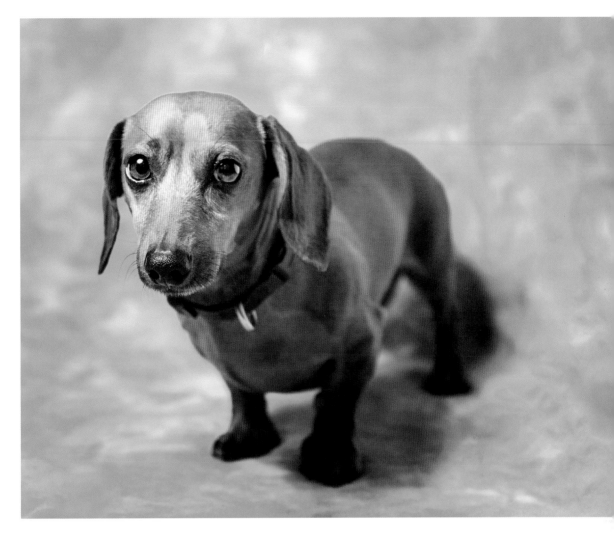

Hoss

(previous page) Hoss, a two-year-old Jack Russell Terrier and Chihuahua mix, was an owner surrender to a high-kill shelter in West Virginia. He was turned in along with a Dachshund named Buck. Sadly, owner surrenders aren't given much time and can be quickly euthanized. Fortunately, Hoss and Buck were pulled by a rescue. Hoss is a sweet, lively dog who spent four months in his foster home before heading to a big adoption event in New York City to find his forever home. He was adopted in May 2016.

Buck

(above) Buck, a six-year-old Dachshund, was surrendered to a high-kill shelter along with Hoss. According to the surrender paperwork, the family had too many dogs, which can be the case in many rural areas. A super friendly and quiet Dachshund, Buck was adopted in February 2016.

Sandy

(below) Sandy was rescued from a high-kill shelter in West Virginia in January 2016. She had recently had babies, but they didn't end up coming to rescue with her. Sandy was listed as a Labrador Retriever mix, but with her short legs, her heritage probably includes Basset Hound. She was very reserved and withdrawn when she arrived at her foster home, but the family fell in love with her anyway and adopted her. She is now called Lucy and is very happy and loved in her forever home.

Hunter

(following page) Hunter, a six-year-old Basset Hound, along with his sister, Molly, was rescued from a hoarding situation in rural West Virgina. Both dogs suffered from neglect, which included a lack of medical care and malnutrition. Hunter was adopted in February 2016.

66 Both dogs suffered from neglect . . . 99

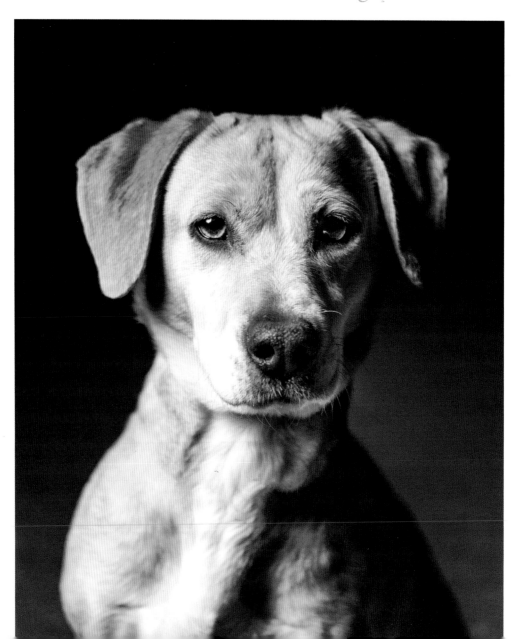

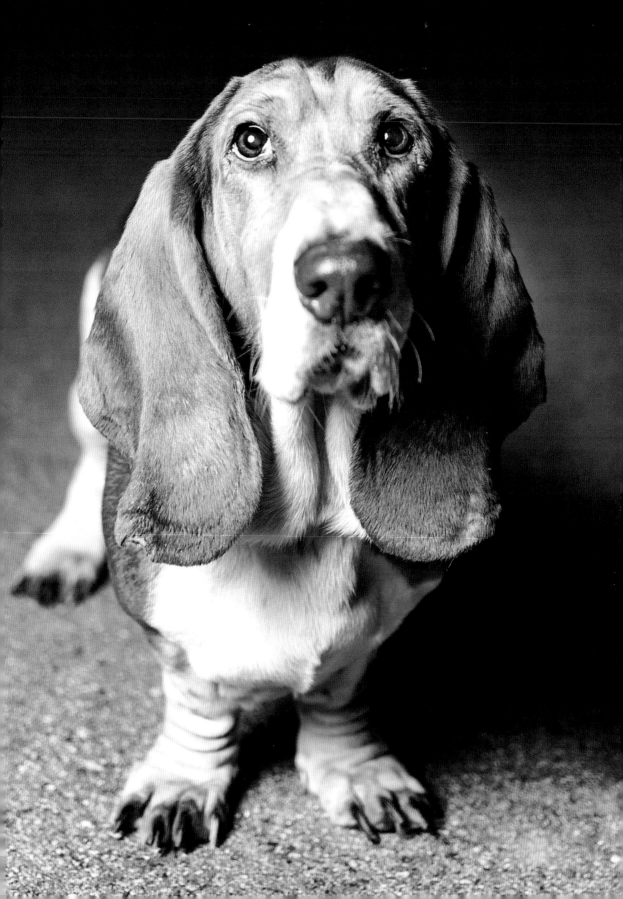

Molly

Molly, a six-year-old Basset Hound, was rescued from a hording situation masquerading as a rescue in rural West Virginia. Held up for a while because of a legal situation, Molly was brought into rescue in January 2016 along with quite a few other dogs, including her brother, Hunter. Molly's foster ended up falling in love with her right away and knew that Molly was already home.

66 Molly, a six-year-old Basset Hound, was rescued from a hording situation masquerading as a rescue in rural West Virginia. 99

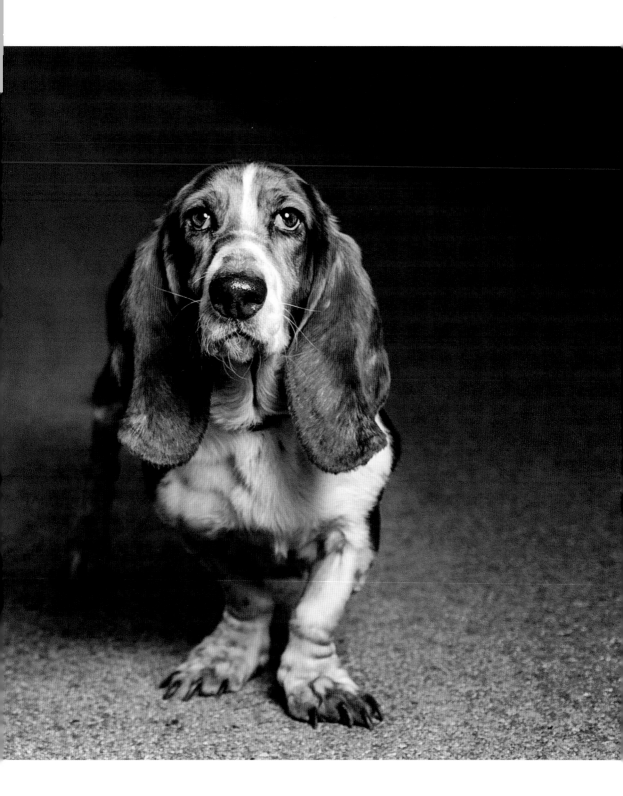

Ben

(below) Ben, a young Labrador Retriever mix, ended up in rescue through no fault of his own. A very friendly and happy dog, he is a typical playful and energetic Lab. He was adopted after a very short stay at a no-kill shelter in February 2017.

Annie

(following page) Annie, a three-year-old Boxer and Foxhound mix, came from a rural kill shelter to rescue. A sweet and friendly girl, she lived in foster care for almost five months before finding her forever home in September 2016.

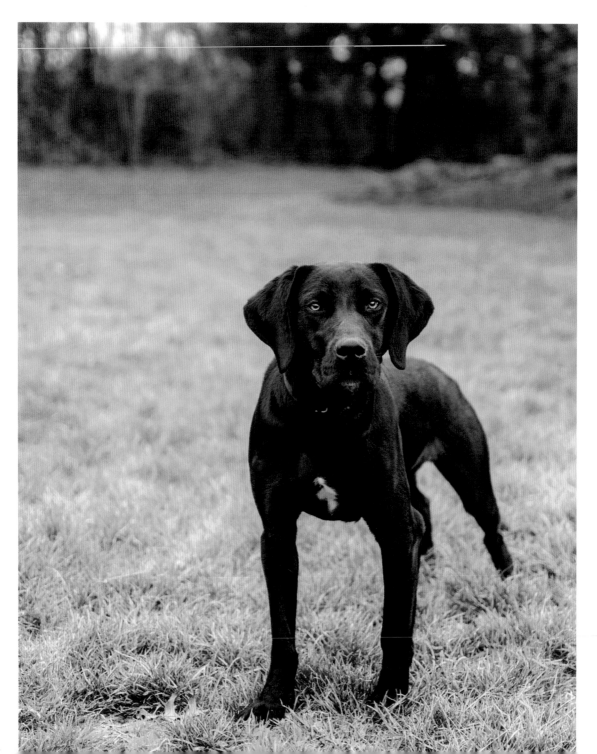

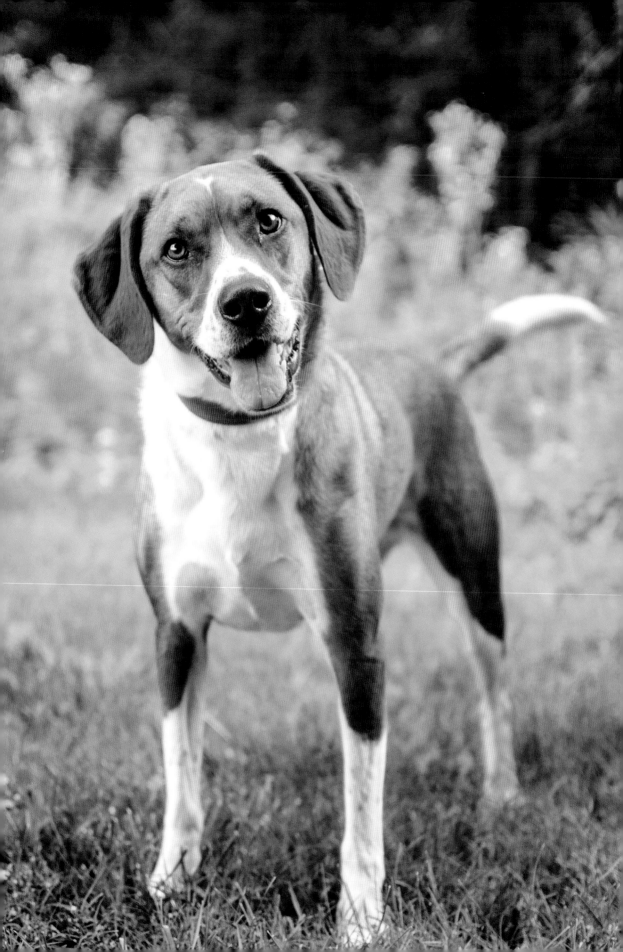

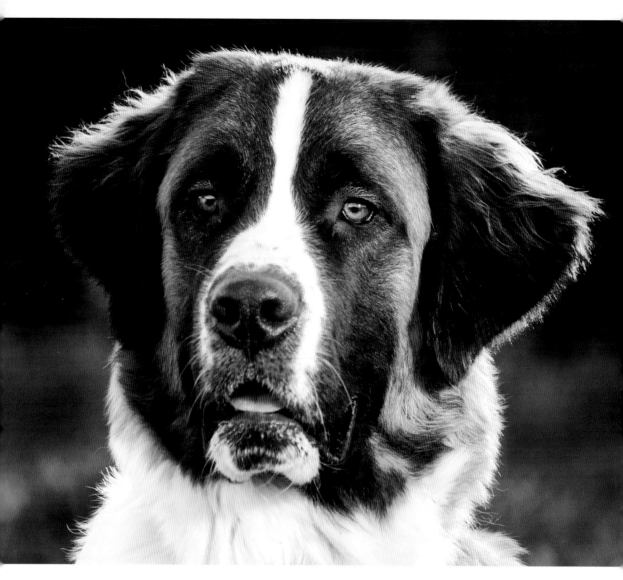

Willow

(above) Willow, a one-year-old purebred St. Bernard, ended up in rescue when her former owners couldn't handle her. This smart girl loves to snuggle. Willow luckily found the right forever home in May 2016.

Rahlee

(following page) Rahlee, a two-year-old German Shepherd mix, came to rescue from a shelter in rural Kentucky. This tall and lean, quiet dog absolutely loves being outside and going for walks. Rahlee will make a cooperative and loyal companion.

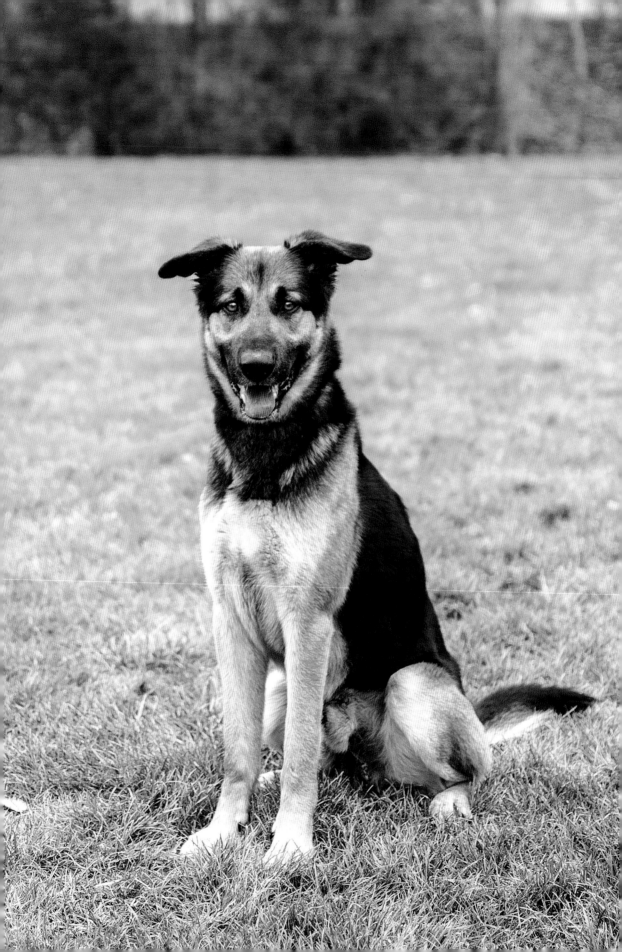

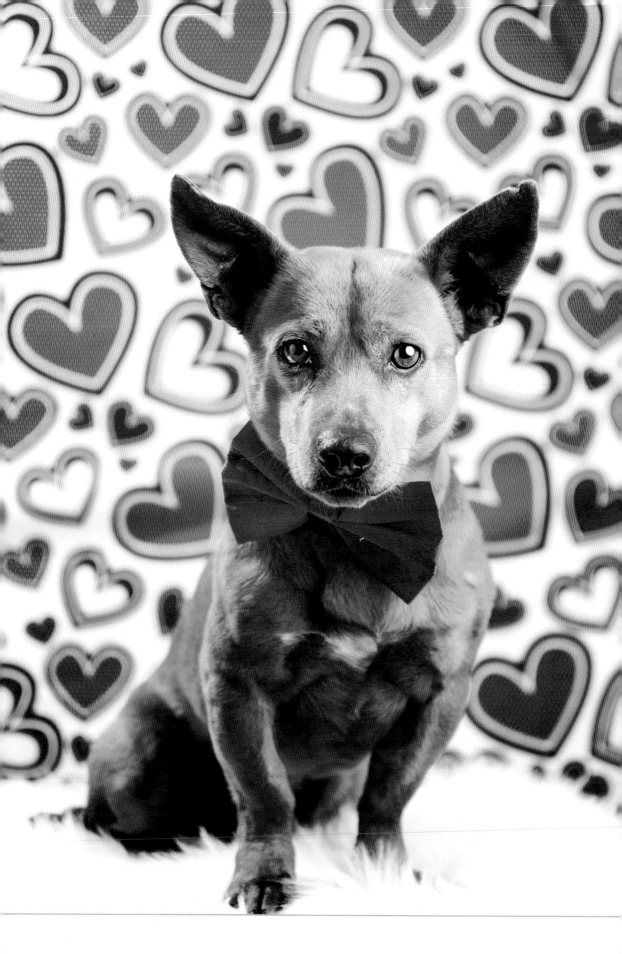

Rufus

(previous page) Rufus, a two-year-old Corgi and Chihuahua mix, came from a rural Tennessee shelter to his foster home. He is a friendly, inquisitive dog with just the perfect head tilt.

If dogs could talk, Rufus would have a tale to tell. This sweet, snuggly guy was adopted by an older couple who was thrilled to have him join their household. Rufus found his home in February 2016.

Noble

(below) Noble, a one-and-a-half-year-old Bloodhound mix, found himself back in rescue as an adult in June 2016 after being adopted out as a puppy. This affectionate dog loves to play; he is a big, goofy hound. Noble is still looking for his happily-ever-after ending.

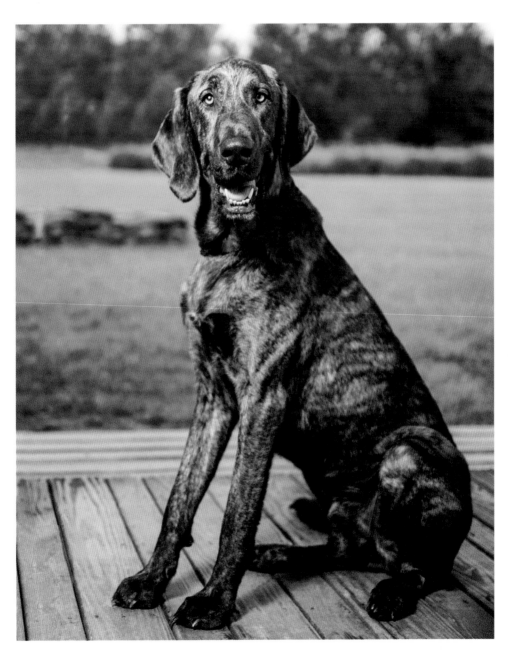

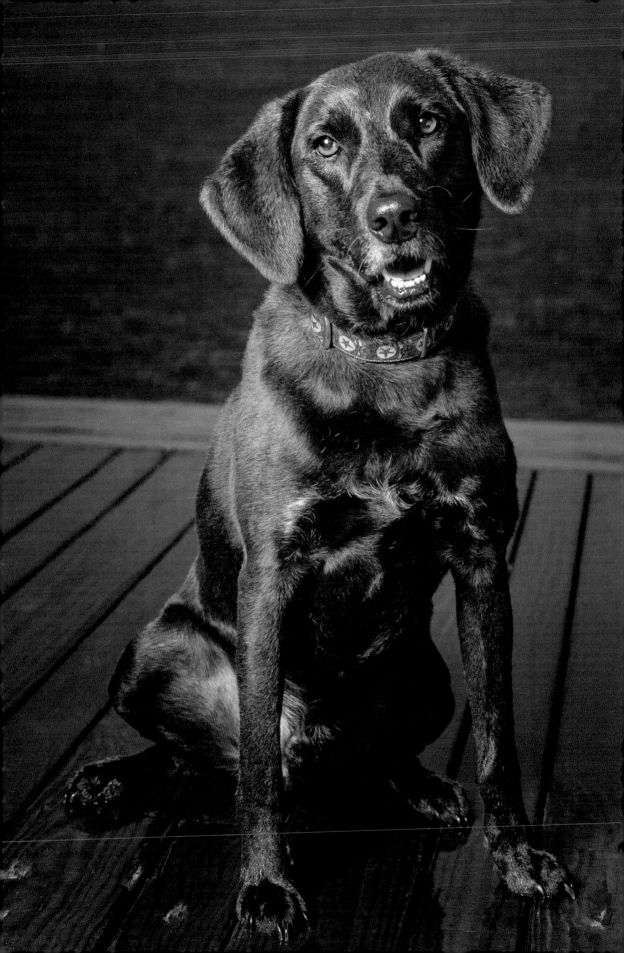

Parker

(previous page) Parker, a four-year-old Labrador Retriever and Weimaraner mix, ended up in rescue when his previous family just didn't have time to deal with him. Luckily for Parker, this friendly Lab mix was able to find a family that did. He was adopted in March of 2016.

Winchester

(below) Winchester, a two-year-old Boxer mix, came from a rural high-kill shelter to rescue. He lived in a foster home where he enjoyed napping and playing outside with his foster family. He was adopted in May 2016.

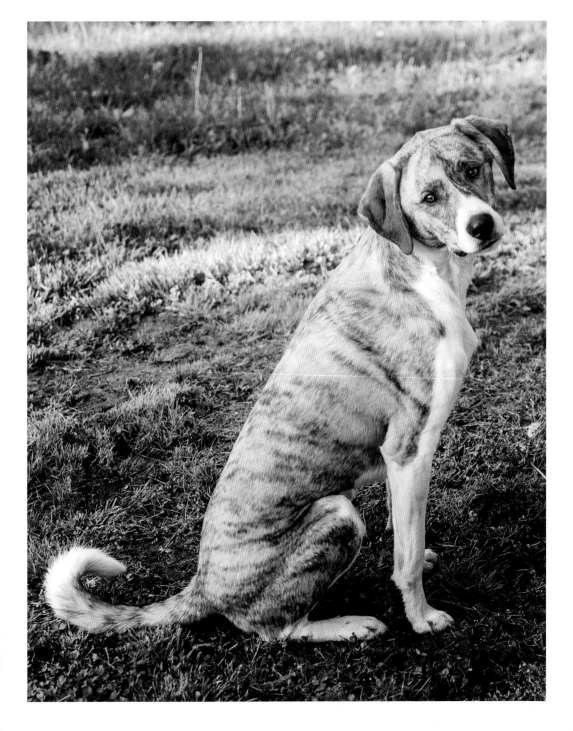

Apollo

(below) Apollo, a handsome one-year-old German Shepherd, ended up in rescue as many young dogs do once a puppy becomes an adult. Apollo is a gentle and loving dog who needed someone to work patiently with him to help boost his confidence. Fortunately, Apollo was able to find the right family in April 2016.

66 Apollo is a gentle and loving dog . . . 99

Porkchop

(following page) Porkchop, a three-year-old Pit Bull Terrier and Jack Russell Terrier mix, ended up in a kill shelter. Sadly, the label "Pit Bull mix" is an almost certain death sentence. Luckily, this adorable tough guy hit the lottery when he was pulled by a rescue. With his short legs, there is assuredly another breed in the mix—perhaps Corgi or Dachshund.

Loving nothing more than snuggling or riding in the car, Porkchop is a great companion. He spent a few weeks on the market interviewing for his forever family before he was finally adopted in May 2016.

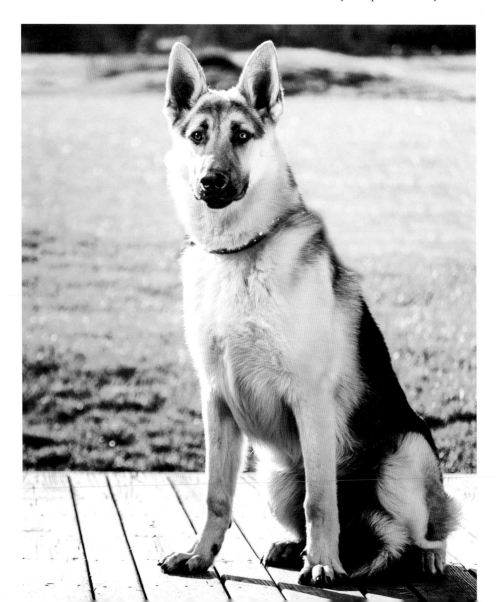

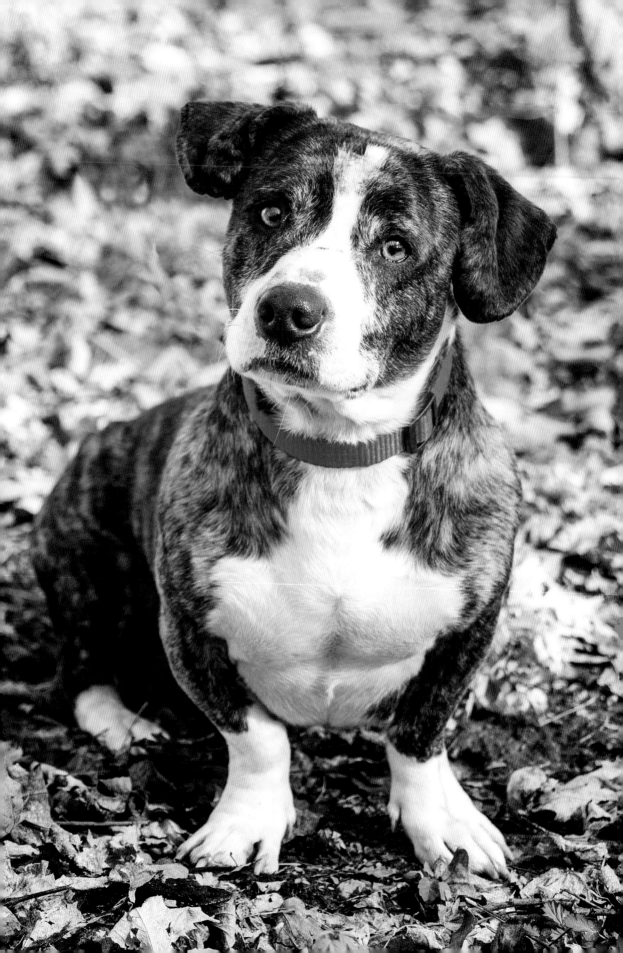

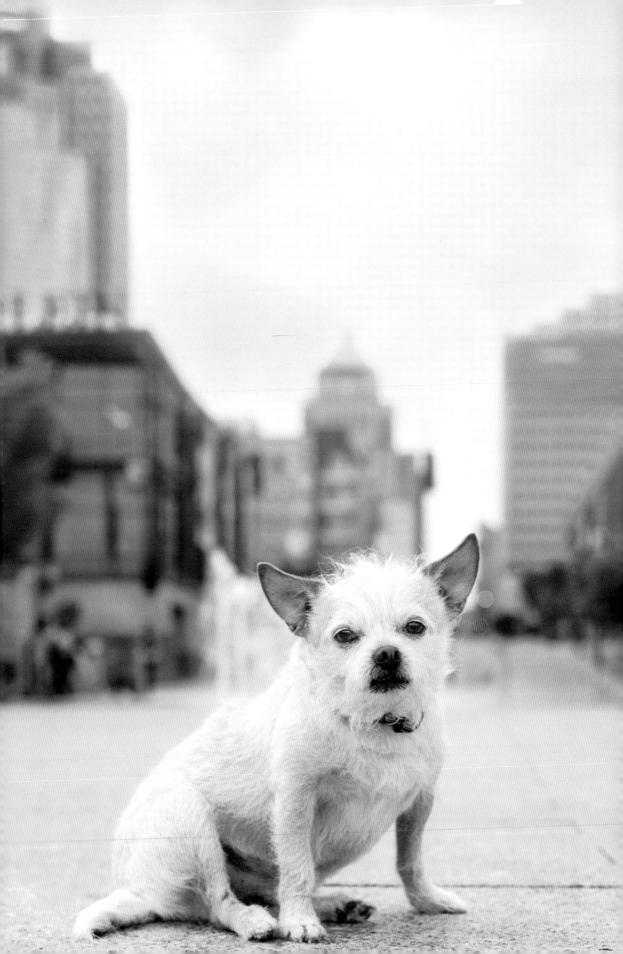

Mr. Bojangles

(previous page and below) Mr. Bojangles was rescued from a rural Kentucky kill shelter and transported to Ohio in early 2011. It is unclear whether he was found as a stray or was an owner surrender, but he was estimated to be two years old at the time. He was named Rags by the rescue, because of his scruffy fur. He was living with his foster mom through the Cincinnati-based rescue, Recycled Doggies, when he was adopted in March 2011. It was love at first sight!

Mr. Bojangles, now eight years old, is a Chihuahua and Cairn Terrier mix and the inspiration behind Pet Love Photography. He is a sweet, loving dog who is a social media celebrity in his own right, with profiles on Facebook, Instagram, and Twitter; he also has his own website. Mr. Bojangles is a frequent model and test subject for Pet Love Photography.

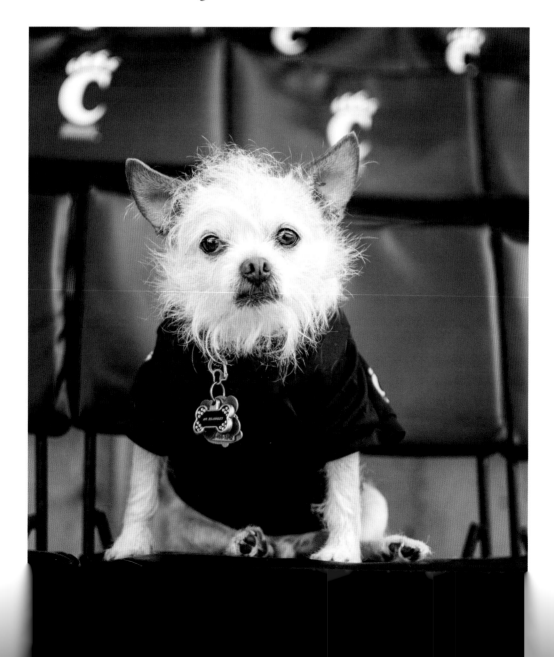

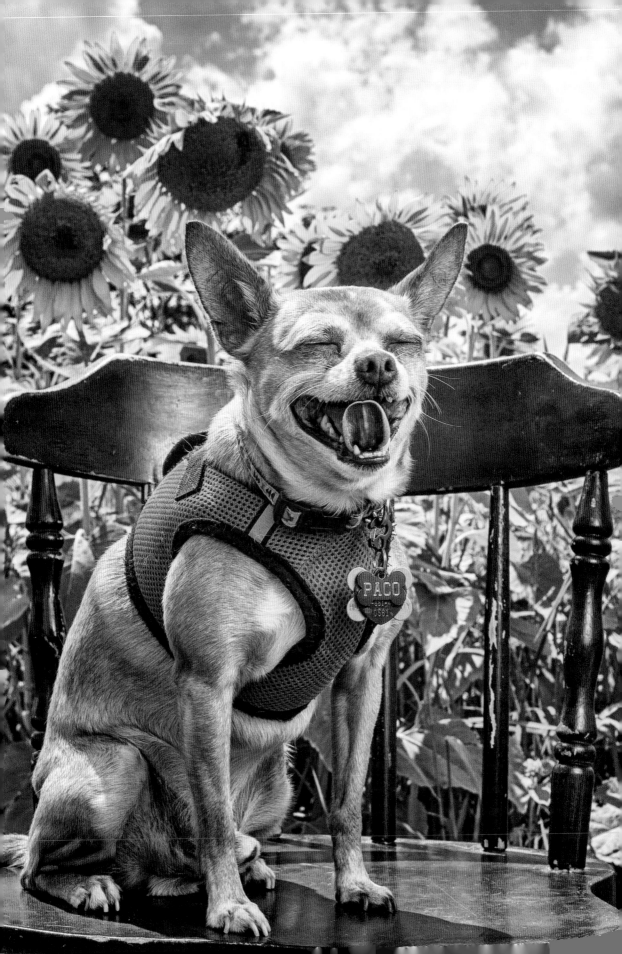

Paco

(*previous page and below*) Paco was rescued from a hoarding situation in West Virginia and, for legal reasons, he was placed on hold prior to coming to rescue. While in foster care, he visited his future home while his foster family was on vacation. He got along well with everyone and, a month later, in February 2016, was adopted into the Pet Love Photography family.

Paco is a shy, yet friendly dog, especially if you have food. He loves people and other dogs, especially big dogs. He is content to let Mr. Bojangles call the shots as long as he gets plenty of snuggle time and snacks. Paco loves to play with his kitty sister, and they spend some time every day chasing each other up and down the hallway of their home.

Gigi

(below) Who says you can't find a purebred in a shelter or rescue? Gigi, a six-year-old full-blooded Shih Tzu ended up in rescue after her elderly owner couldn't afford her medical care. Gigi had a severe case of bladder stones and needed surgery. Fortunately, she was surrendered to a rescue rather than being euthanized and was able to receive the medical care she needed. It was not without much heartache for the owner who had to give her up, though. Luckily, Gigi recovered and was adopted into a loving new family in July 2016.

Bambi

(following page) Bambi, a one-year-old Belgian Malinois mix, is a smart and social dog that was rescued from a rural high-kill shelter. She lived in foster care until she was adopted by a loving family in July 2016.

❝ Bambi, a one-year-old Belgian Malinois mix, is a smart and social dog . . .❞

Tinkerbell

(above and following page) Tinkerbell, a lively one-year-old Yorkshire Terrier and Chihuahua mix, was turned in to a shelter because she was allegedly aggressive toward both cats and chickens. At all of five pounds, Tinkerbell is full of personality, as demonstrated by this image. No shrinking violet, Tinkerbell holds her own against her foster brothers during playtime.

Tinkerbell was destined for a big adoption event in New York City, so wanted to show her serious and sophisticated side *(following page)*, as well. She was adopted in May 2016 by a young couple who were excited to have her join their family. She is the center of attention wherever she goes and lives in loving harmony with her new kitty sibling.

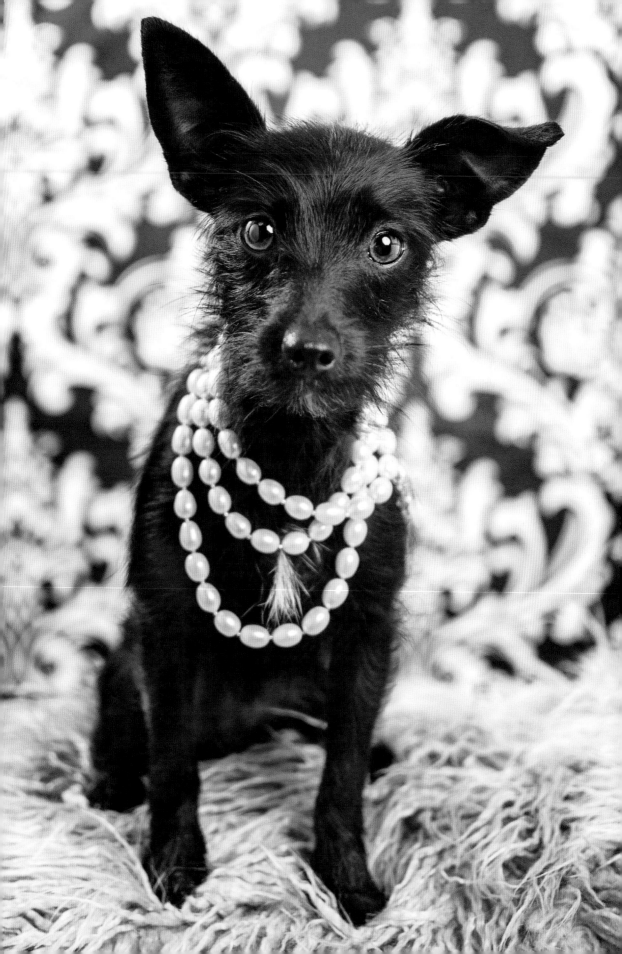

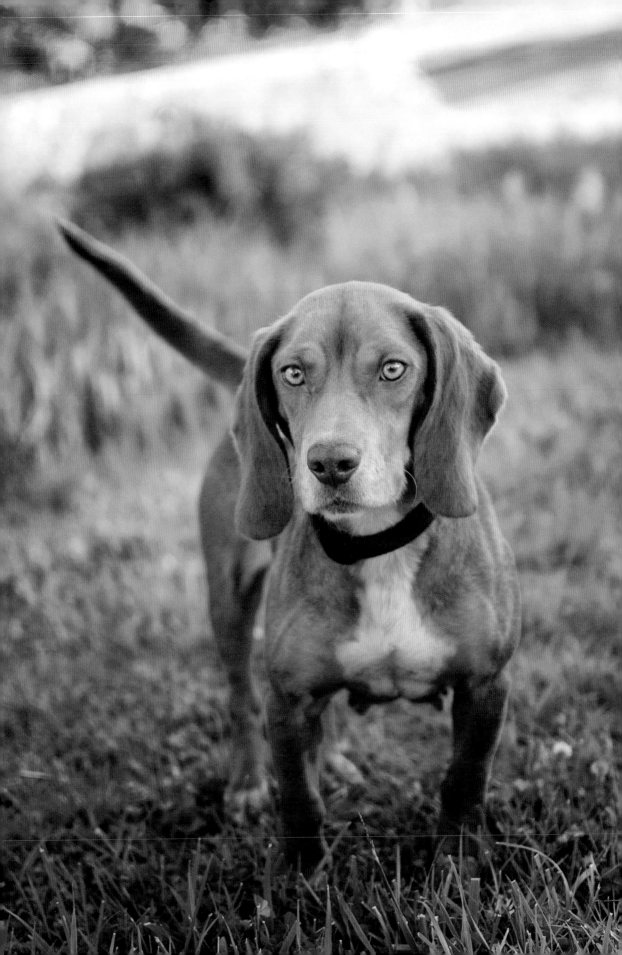

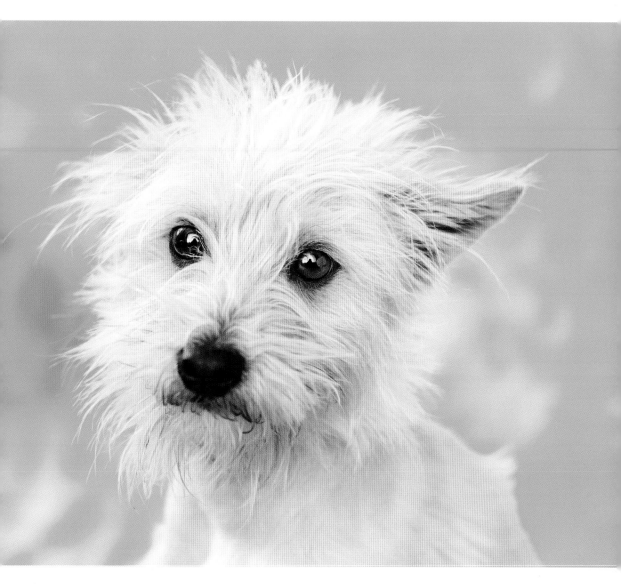

Spice

(previous page) Spice, a two-year-old Beagle mix, had puppies and was dumped at a rural kill shelter. She was pulled by a rescue but suffered from kennel cough and was covered in ticks. She recuperated at her foster home and was adopted by her new family in May 2016.

Ozzy

(above) Ozzy, a one-year-old Cairn Terrier and Pomeranian mix, came to rescue from a rural Ohio shelter. He had been severely neglected. His collar was too tight and had embedded itself in his neck, so his fur had to be shaved down around his neck for it to be removed and to allow his skin to heal. Ozzy was adopted into his forever home in January 2016.

Hugo

(below) Hugo, a tiny four-year-old Chihuahua, was rescued from a hoarding situation in rural West Virginia along with several other dogs. He bonded quickly with his foster family and ended up being what is called a "foster fail." Sadly, Hugo ran off from his home in Pataskala, Ohio, while his new dad was in the hospital fighting cancer in April 2016. He is still missing.

Griffin

(following page) Griffin, a young Shih Tzu and Lhasa Apso mix, somehow ended up with a rescue. It's hard to believe that such a people-loving, happy, and sweet guy could end up without a home. Fortunately, Griffin didn't have to wait long to find just the right family. He was adopted in New York City in May 2016.

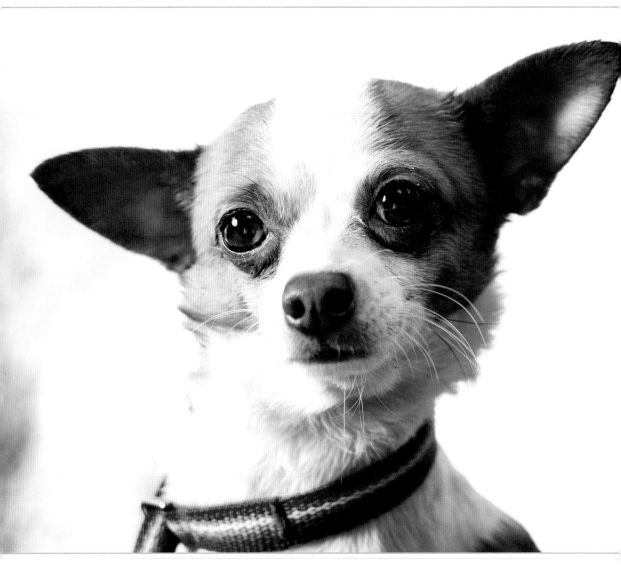

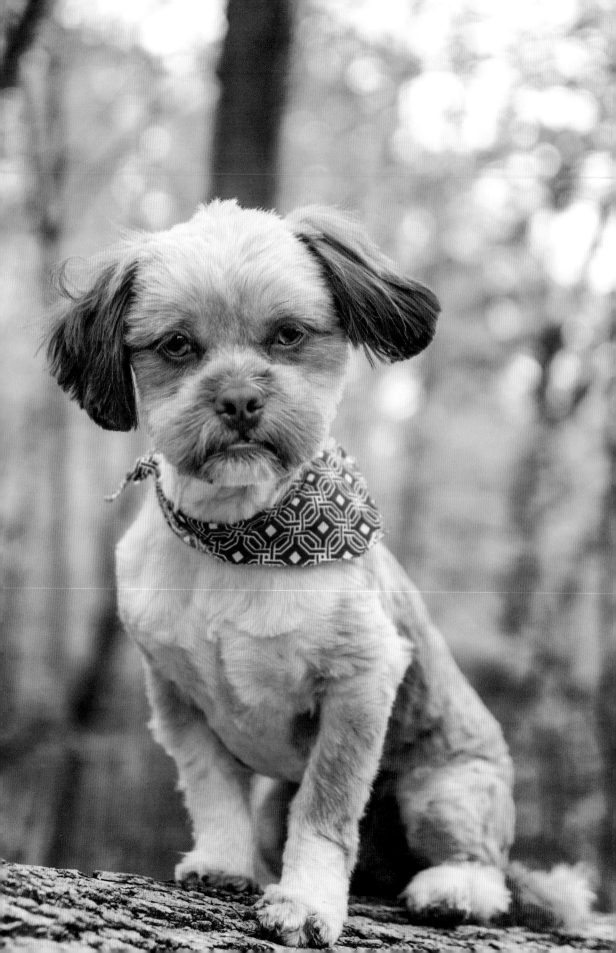

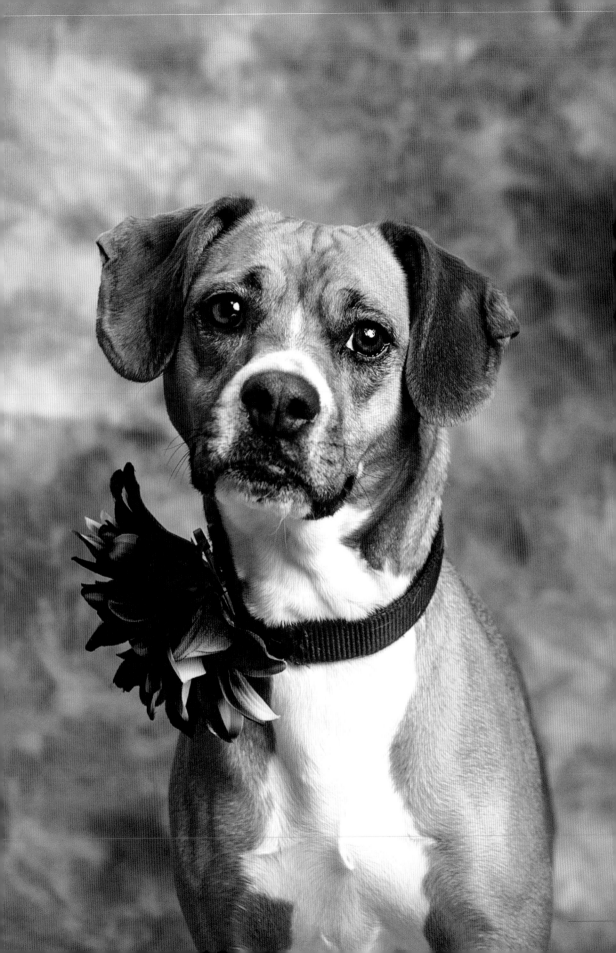

Sharlie

(previous page) Sharlie, a beautiful two-year-old Boxer and Beagle mix, ended up in a no-kill shelter where her light could shine. After a brief stay with the rescue, this lovely lady was snapped up by her adoptive family in February 2017.

Trinity

(below) Trinity, a three-year-old Corgi and Jack Russell mix, ended up in a rural kill shelter after giving birth. While her puppies didn't end up in rescue with her, she was saved to find a better life and end her days of motherhood. She found her forever home in June 2016.

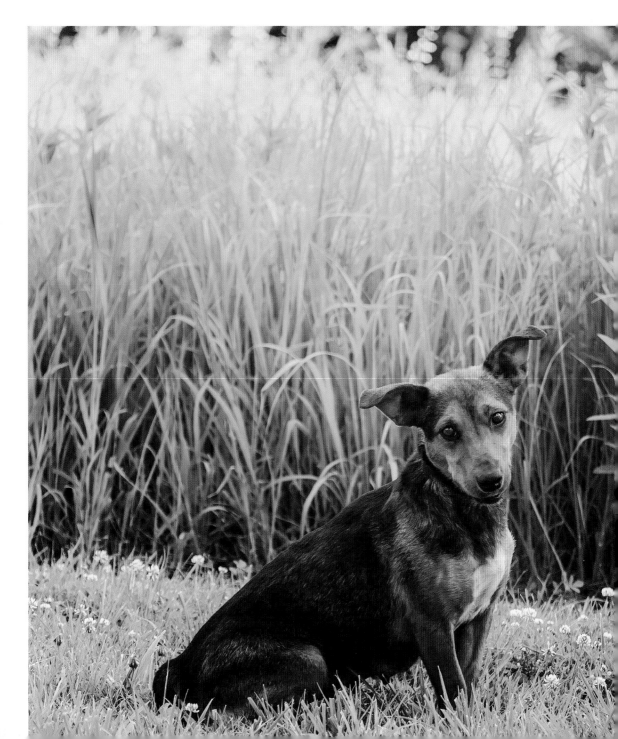

Phoenix

(below) Phoenix, a two-year-old Shih Tzu and Terrier mix, ended up in a rural shelter, but her luck turned when she was pulled by a rescue. This energetic and intelligent girl was adopted in April 2016.

" This energetic and intelligent girl was adopted in April 2016. "

Gatsby

(following page) Handsome Gatsby, a one-year-old Rhodesian Ridgeback and Hound mix, was adopted out as a puppy—twice—before ending up back at the local no-kill shelter as a young adult. His new mom fell in love with him because he's a big, clumsy guy who ran exactly how she thought Scooby-Doo would run. Gatsby's mom says he is a lovable and playful pup, and she couldn't be happier to have him as part of her family. He joined his new family in November 2016 and is now named Bruce.

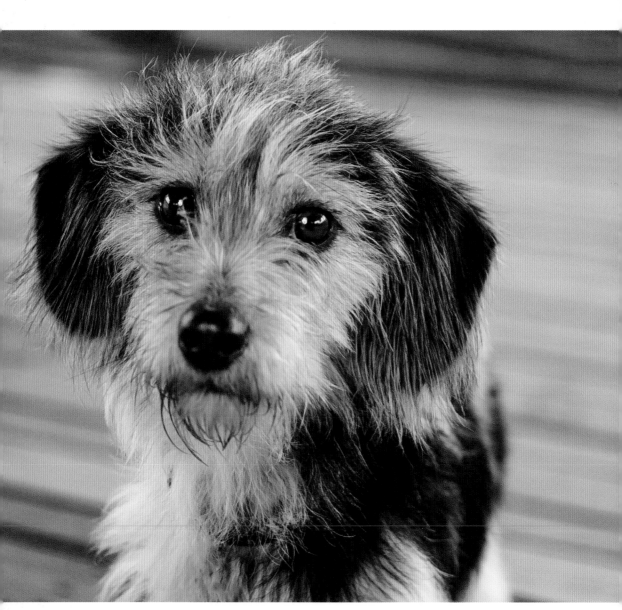

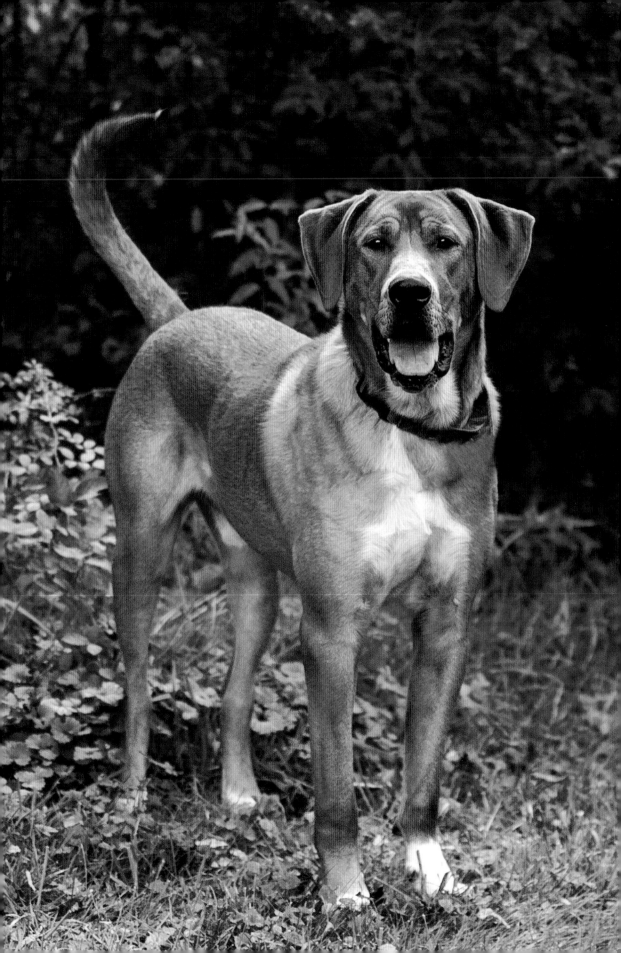

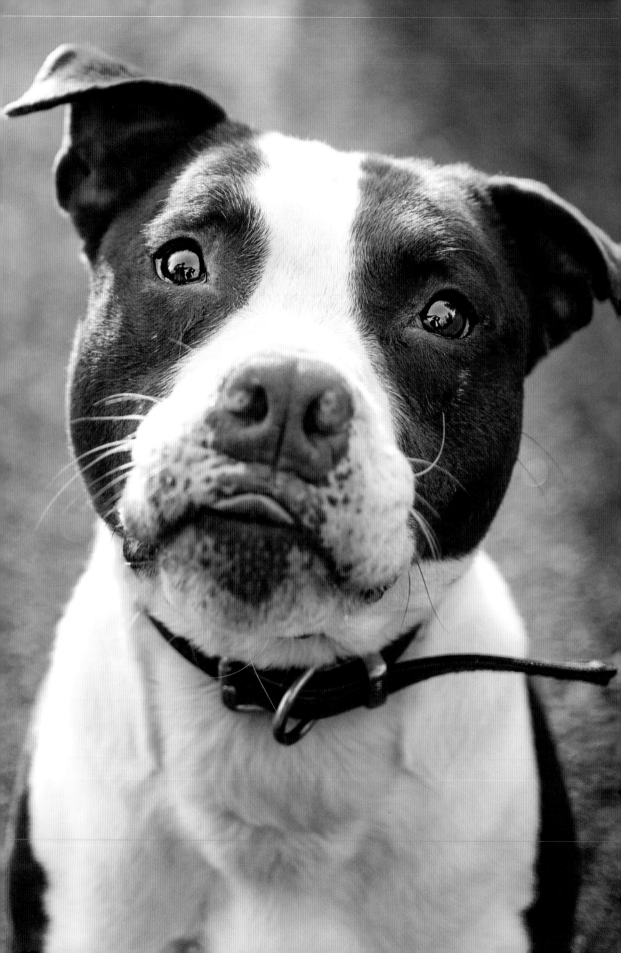

Tyson

(previous page) Tyson, a five-year-old Pit Bull Terrier and American Staffordshire Terrier mix, has been in rescue for over a year. In a shelter environment being any kind of Pit Bull mix (or even looking like one) can be an almost certain death sentence. Even in rescue, it is often hard for a dog like Tyson to get adopted because of the stigma associated with Pitties. Tyson is an affectionate guy who just wants to be loved. He is still waiting to find the perfect home.

Rusty

(below) Rusty, a two-and-a-half-year-old Wheaten Terrier and Airedale Terrier mix, ended up in rescue after his owner could no longer take care of him. A calm, affectionate dog, Rusty enjoys playing and running in the yard. He was adopted in May 2016.

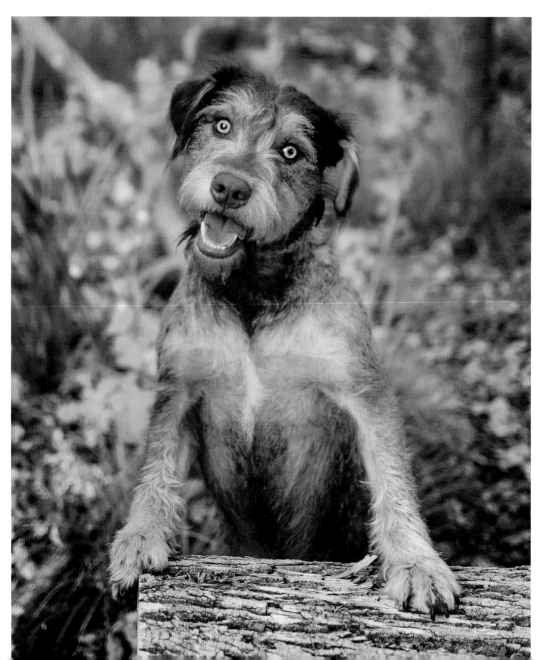

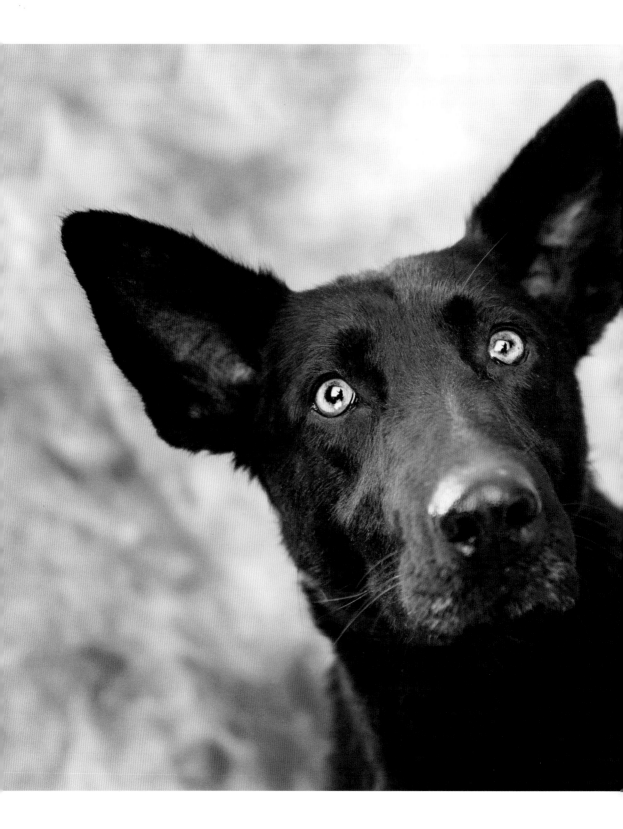

Ninner

Ninner, a roughly three-year-old German Shepherd and Labrador Retriever mix, was rescued from a life of horror chained outdoors in a rural Ohio county. At the time she was rescued, she had several puppies, and, sadly, not all of them were alive; however, four of her pups were rescued with her. Mom and puppies sat in limbo for a while as their former owner was prosecuted for their neglect. They were then brought into rescue, and puppies Jana, J-Lo, Jamie, and Jasper were adopted in January 2016. Ninner suffered the fate that many black dogs do and waited for a home . . . and then waited some more. However, as soon as her adopter saw her picture, she knew she had to have Ninner. Ninner was adopted in February 2016. Now named Duchess, she lives a happy life with her new family, which includes kids, cats, and another dog. She is a calm and gentle dog who patiently waited in her foster home before finding her happily ever after.

66 Mom and puppies sat in limbo for a while as their former owner was prosecuted for their neglect. 99

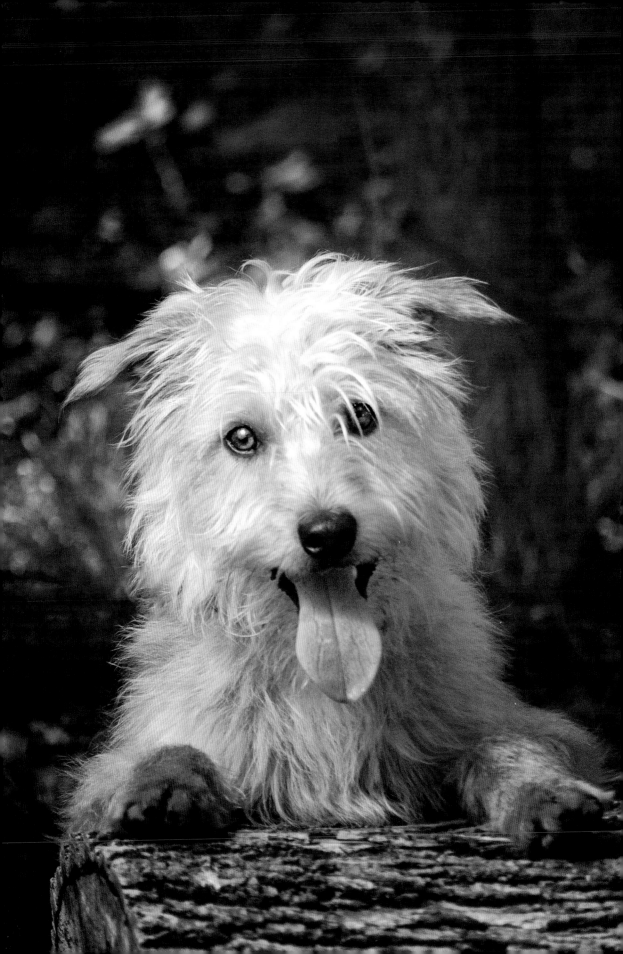

Flynn

(previous page) Flynn, a three-year-old Wheaten Terrier mix, was saved from a rural high-kill shelter with a severe case of parvo, which can be fatal to dogs, especially if they are in a shelter. Luckily for Flynn, he was rescued and nursed back to health. He was adopted and then returned but finally found his forever home in October 2016.

Nikita

(below) Nikita, a Siberian Husky mix, is an energetic young dog who likes to play. She came to rescue from a rural high-kill shelter and was adopted in May 2016.

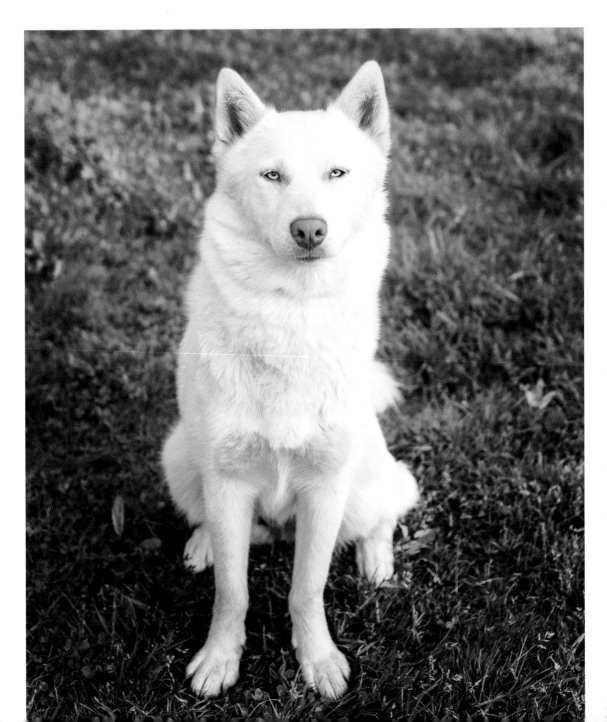

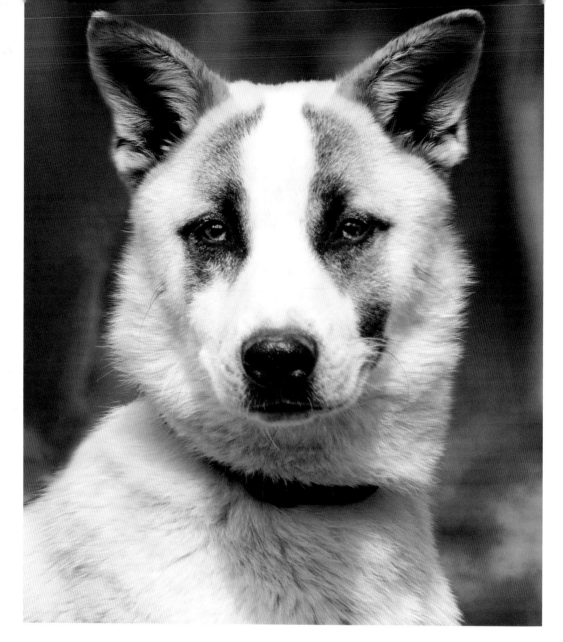

Kramer

(above) Kramer, a handsome one-year-old Siberian Husky and Shiba Inu mix, somehow ended up at a rural shelter, subsequently finding his way into rescue. Full of personality, Kramer has a lot of love to give. Fortunately, he was able to find his perfect forever home in May 2016.

Donna

(following page) Donna, a three-year-old English Coonhound mix, was brought into rescue from a rural shelter along with her three-day-old litter of ten puppies in December 2015. Donna lived in foster care for over a year before she finally found the right forever family. She was adopted in January 2017.

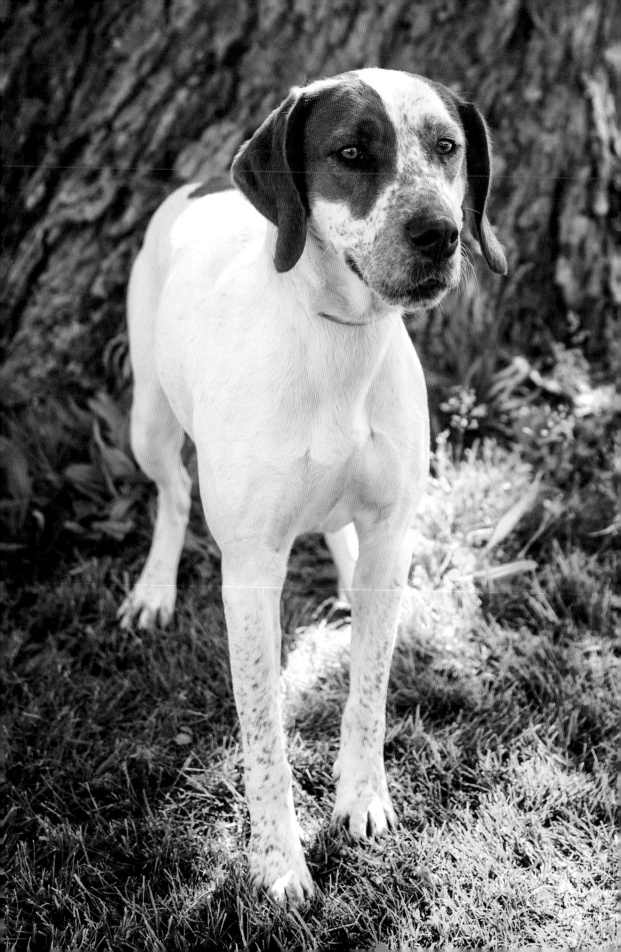

Toby

(below) Toby, a seven-year-old Tibetan Spaniel mix, was rescued from a shelter in Kentucky and brought to a rescue in Ohio. He was in bad shape when he was rescued; it seemed that he'd been hit by or thrown from a car. However, those days are behind him, and this happy, friendly, and well-behaved dog lives the life of luxury in his forever home. He is very social, frequently goes on outings with his mom, and makes friends wherever he goes. He lives with his brother, Oliver, also a rescue dog.

Lolita

(following page) Lolita, a spunky one-and-a-half-year-old Pomeranian and Chihuahua mix, came from a high-kill shelter in West Virginia. Lolita is a fun-loving and friendly girl who, despite being stood up twice at adoption events, was adopted by a family after just a few times out. Her owners are happy to have her and can't get enough of the joy Lolita brings.

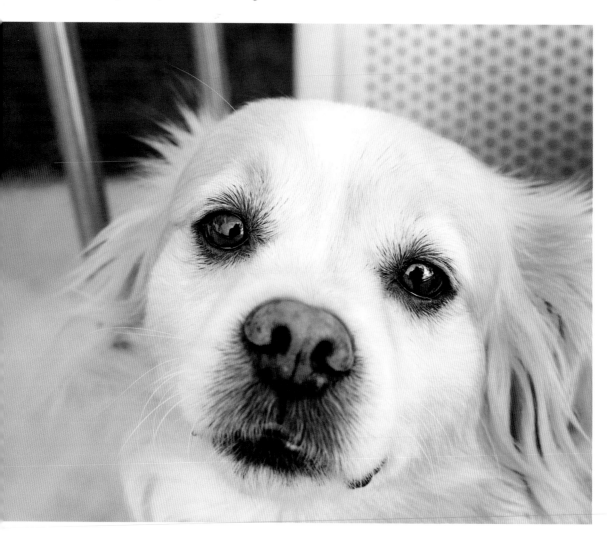

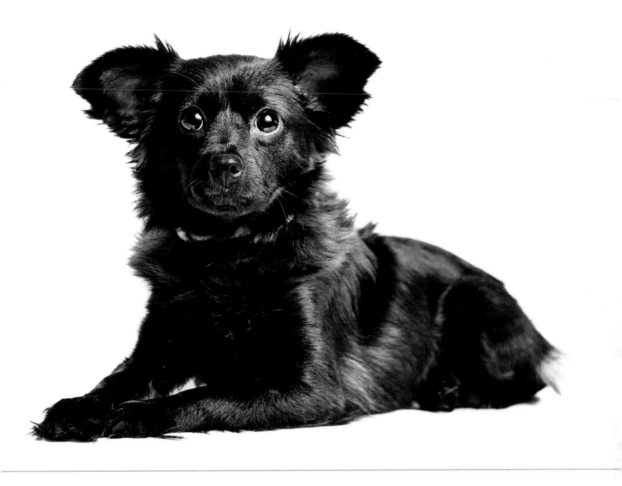

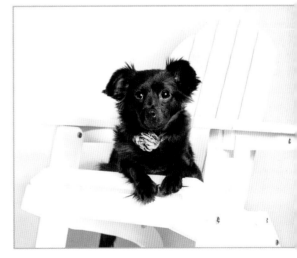

Hunter

(below) Hunter, a five-year-old Golden Retriever mix, came to rescue from a rural area. He loves stuffed toys and frequently carries one around in his mouth. He was adopted in February 2016 and returned a few months later. If possible, when a dog is returned to a foster-based rescue, the dog will go back to the same foster. Hunter was adopted for the second, and hopefully final time, in July 2016.

Sadie Lou

(following page) Sadie Lou, a six-year-old Bullmastiff and English Mastiff mix, was brought into foster care with a rescue. She suffers from arthritis and needs to take medication and supplements daily, but that doesn't stop her from playing with toys or other dogs. She was adopted in February 2016 to a family who couldn't be more thrilled to have her join them.

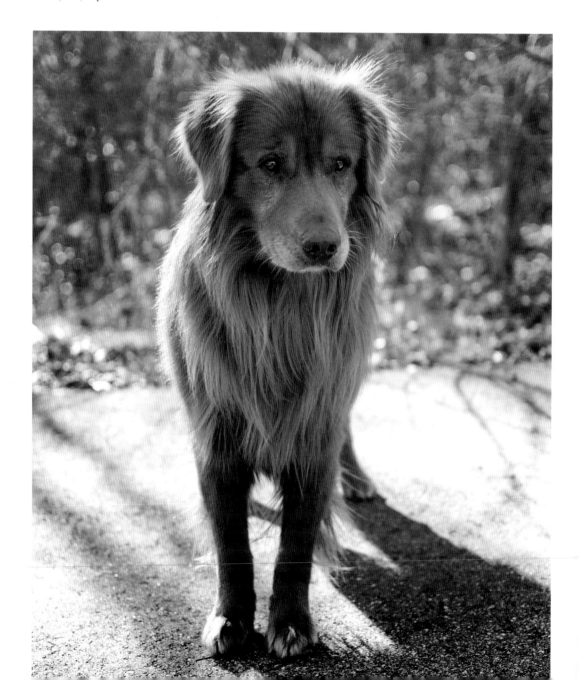

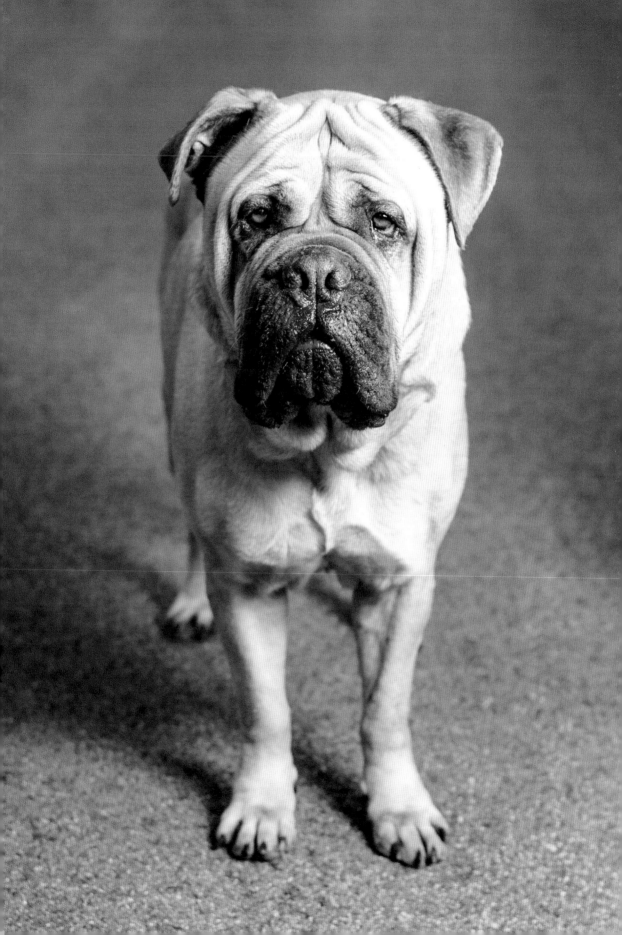

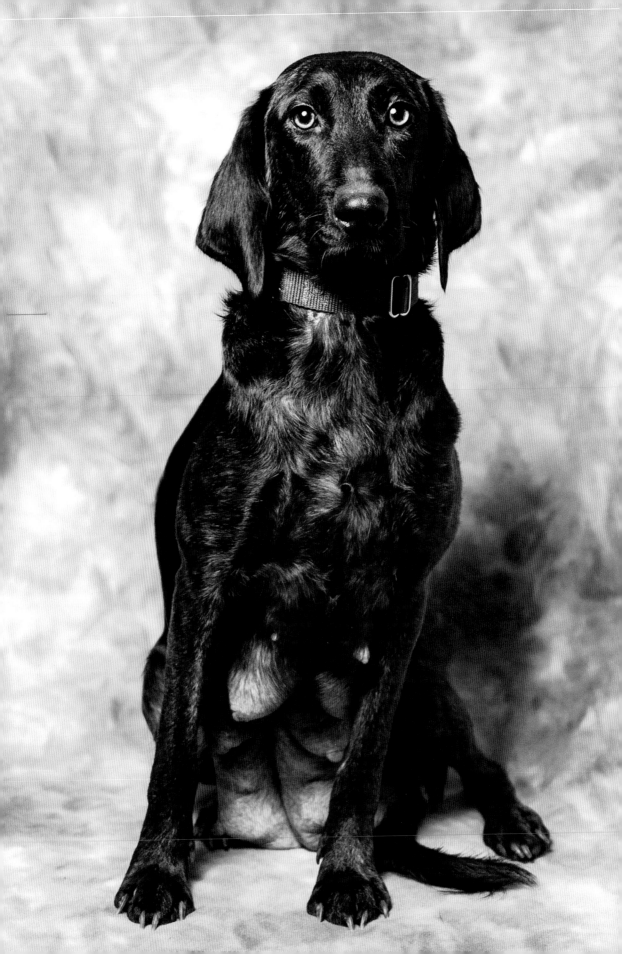

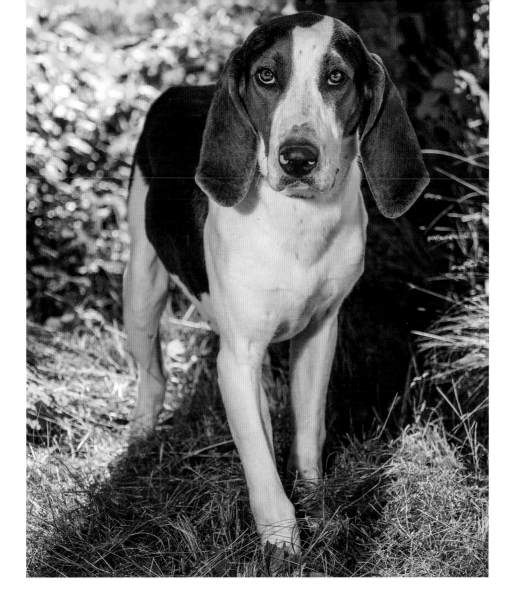

Jenna

(previous page) Jenna, a two-year-old
Bloodhound and Plott Hound mix, was
a maternity foster. She was pulled from a
rural shelter while pregnant in time for her
babies to be born in their new foster home.
Maternity fosters generally aren't adopted
out until after the puppies are ready for
adoption. This quiet, food-loving hound
was adopted in February 2016.

Sadler

(above) Sadler, a two-year-old Treeing
Walker Coonhound mix, came from a rural
kill shelter, as many dogs like him do. Sadly,
in rural areas, dogs—particularly hounds—
are not valued as household pets. Sadler is a
reserved dog. It takes him a while to warm
up to new surroundings and even longer to
acclimate to new people. He spent over six
months in his foster home before he was
finally adopted in February 2017.

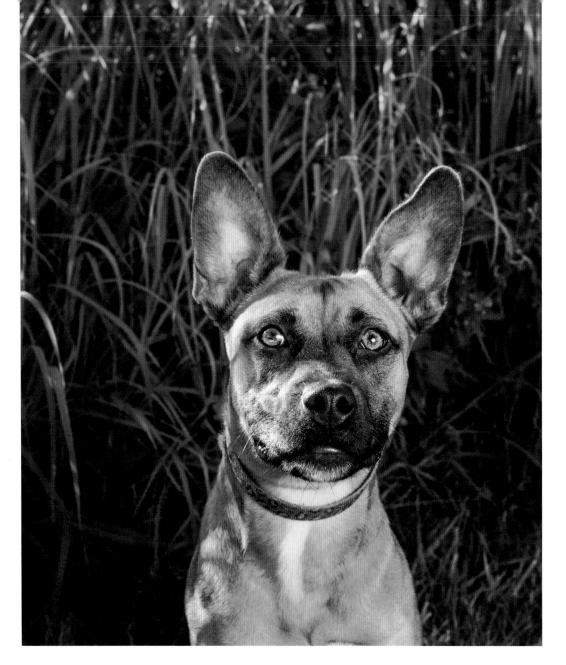

Ritter

(*above*) Ritter, a year-and-a-half-old female French Bulldog and Jack Russell Terrier mix, was pulled from a high-kill rural shelter. A happy, friendly dog, Ritter lived in a foster home until she was adopted in August 2016 after several weeks of attending adoption events.

Murphy

(*following page*) Murphy, a two-year-old low-riding Basset Hound and Labrador Retriever mix, was adopted from his rescue while still a puppy. Even better, his new mom's sister adopted Murphy's brother, Mac, so the two furry family members could enjoy frequent play dates.

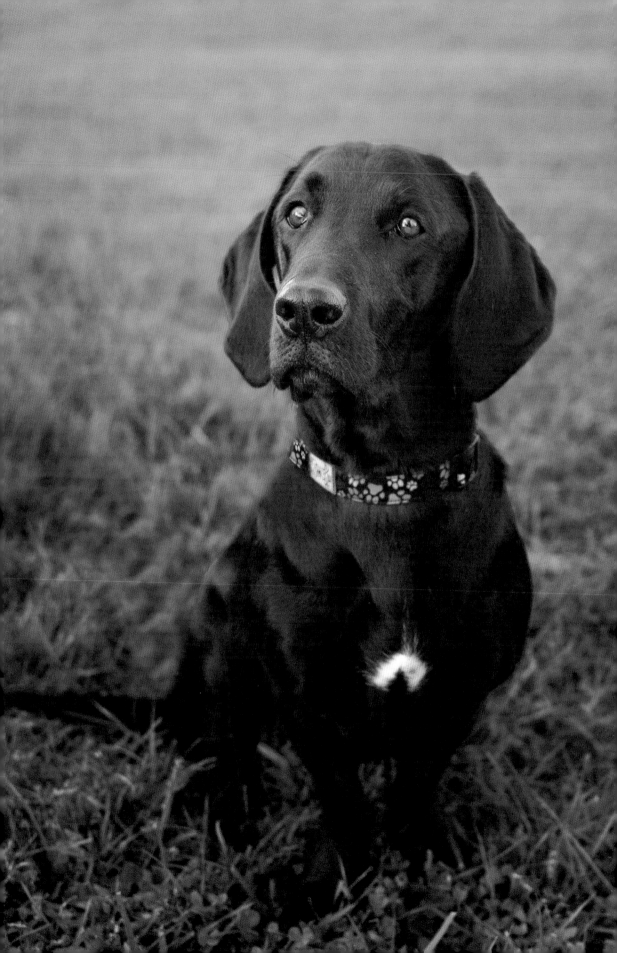

3 SENIORS

Stanley

Stanley, a senior Beagle, was picked up as a stray by a rural Indiana rescue in 2007. He wasn't in the best shape, but was taken in and cared for in a foster home. Unfortunately, in a lot of rural areas it isn't uncommon for Beagles and other hounds to be abandoned when they are no longer useful as hunting dogs. Stanley was of an unknown age and had not had the best life prior to being rescued. He had fractured teeth and an injured paw. It was later discovered that he had a BB lodged under his skin, so had been shot at some point in his past. Despite Stanley's rough history, he was a good dog who got along well with most other dogs and cats. While a little hesitant around most men, he was still a friendly and well-behaved dog, with the exception of his extreme separation anxiety. Stanley lived a good, well-loved, and happy life in his new home for over five years, prior to passing away from cancer in September 2012.

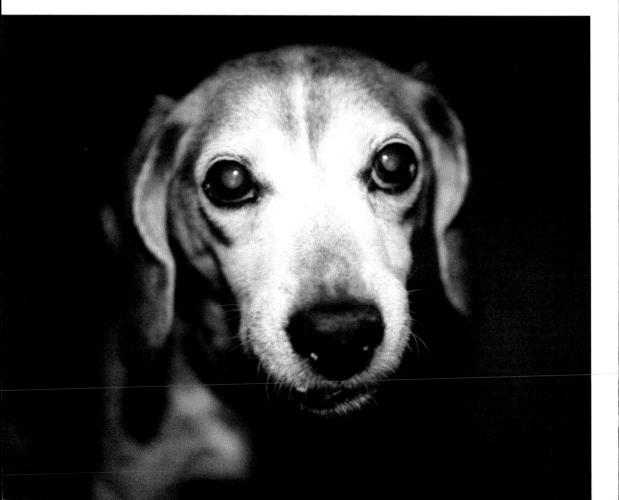

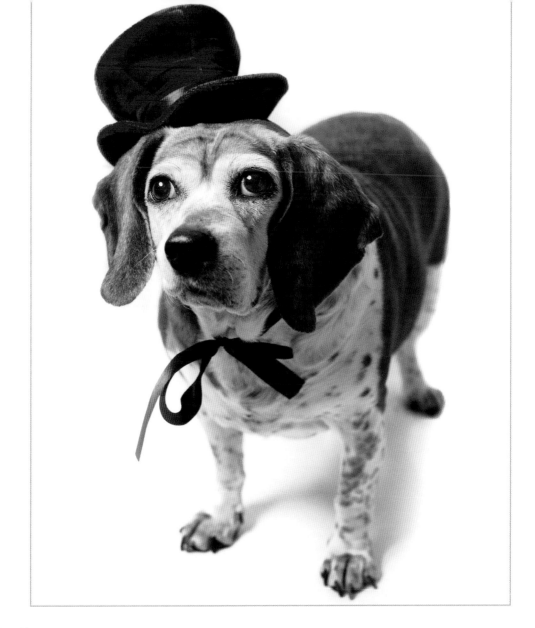

Stella

Stella, a senior Beagle and Basset mix, was adopted in 2008 from a rescue in rural Indiana. According to the rescue, she was adopted and then returned by a family whose daughter was allergic to dogs. Oftentimes, allergies are used as an excuse to return a dog if there are other issues, such as behavioral concerns, that adopters don't want to deal with.

When Stella's new family adopted her, it was discovered that, though she was crate trained, she was not housebroken. Stella was adopted to be a companion to Stanley, the Beagle, and they formed a close bond, only broken by Stanley's death. Stella enjoys her golden years with lots of sleeping, sniffing (which she prefers to do on walks), and eating.

Paisley

(below) Paisley, a senior Poodle mix, was rescued from a rural shelter and brought into rescue. She spent time in the rescue's kennel while recovering from a case of ringworm and was later placed in foster care. She was mostly blind and fairly deaf but managed to get around quite well. Her adopter fell in love with her from her pictures and drove several hours to adopt her in January 2016. Sadly, Paisley passed away later that year, but at least was able to spend her final days in a loving home.

Bowie

(following page) Bowie, a senior West Highland Terrier and Cairn Terrier mix, ended up in rescue after his elderly owner could no longer care for him. Bowie's care had been neglected by his prior owner, as it was discovered that he had some hearing issues because of a severe ear infection that had been left untreated until he came to live in his foster home. He also had some vision problems because of cataracts, but that posed no problem to him getting around his foster home. This intelligent, sweet, friendly guy lived with his foster family for about two months before being adopted in May 2016 by a family in New York who spoils him and loves him unconditionally.

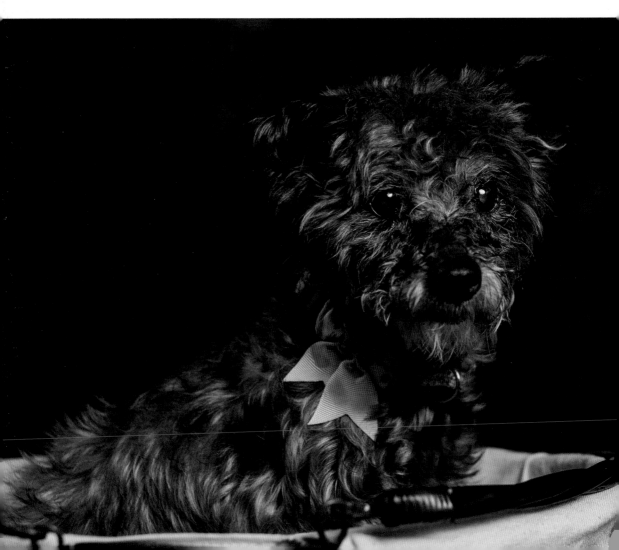

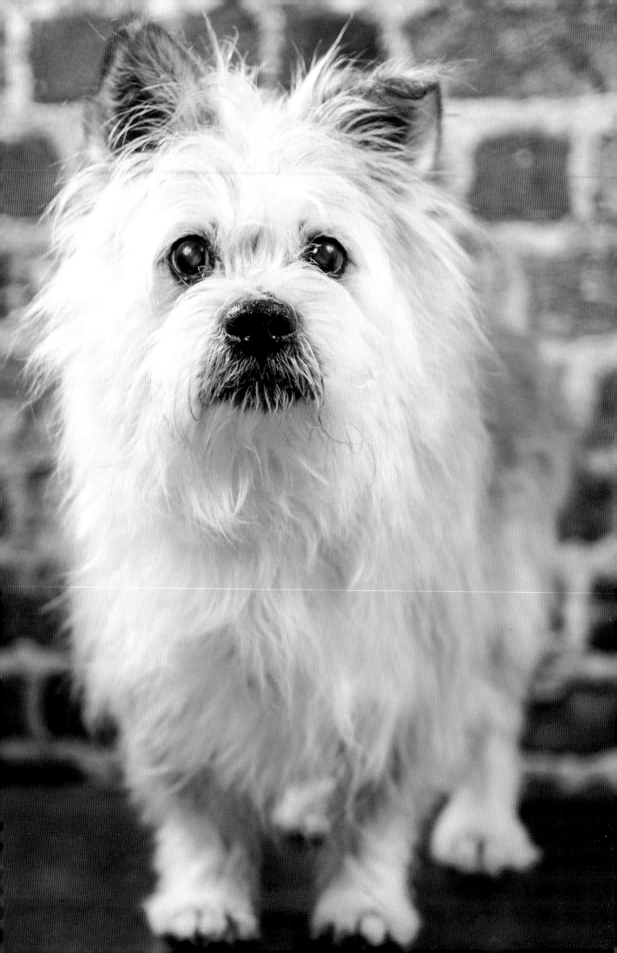

Mike

Mike, now ten years old, was adopted in 2013 from a rescue that found him running down the street. Since no one came to claim this Cattle Dog mix, he was put up for adoption. He was named Albert Einstein by the rescue because he was so smart, but his new owner didn't feel the name fit. She called out a bunch of different names to the dog, and he gave his approval to the name Mike.

Mike loves to stay active. He goes camping and hiking, travels, and attends sporting events whenever he can. His mom says he is the best companion and sidekick, and she couldn't be more thrilled to have Mike as part of the family.

66 Mike, now ten years old, was adopted in 2013 from a rescue that found him running down the street. 99

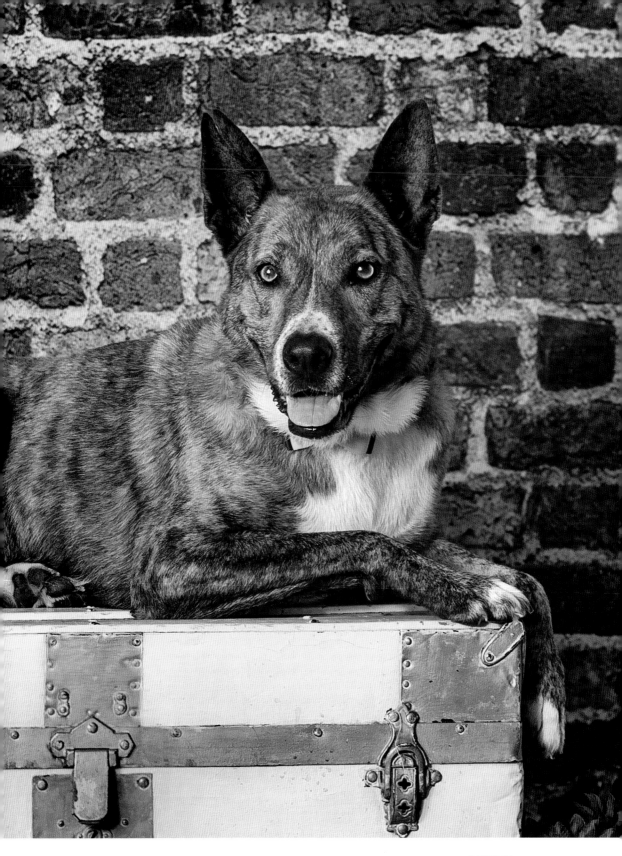

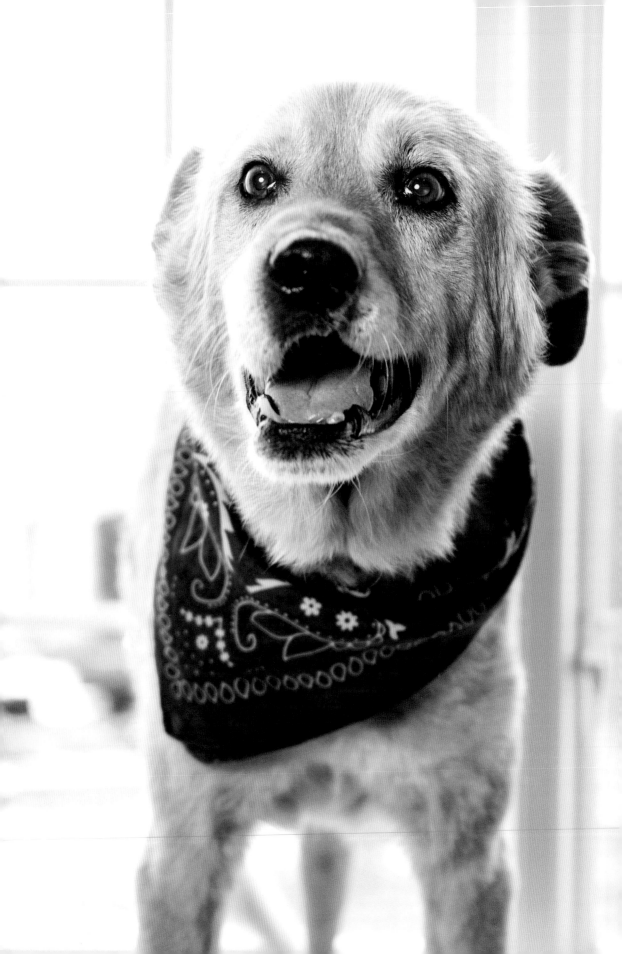

Jackson

(previous page) Jackson, a senior Labrador Retriever and German Shepherd mix, was rescued from a rough life in a rural Ohio county. He had suffered from years of neglect but remained a sweet and friendly dog. It is often hard to find homes for senior dogs, but Jackson quickly won the heart of a rescue volunteer with his crooked smile and was adopted in February 2016. He was given a very good life in his forever home and was very loved. Sadly, Jackson passed away in February 2017.

Dottie

(below) Dottie, a senior Black and Tan Coonhound mix at over ten years of age, was adopted very quickly because her adopter fell in love with her just from seeing her adoption picture. Having professionally taken adoption photos can frequently be the difference between a dog finding a home quickly or languishing in rescue. Dottie was adopted in April 2016.

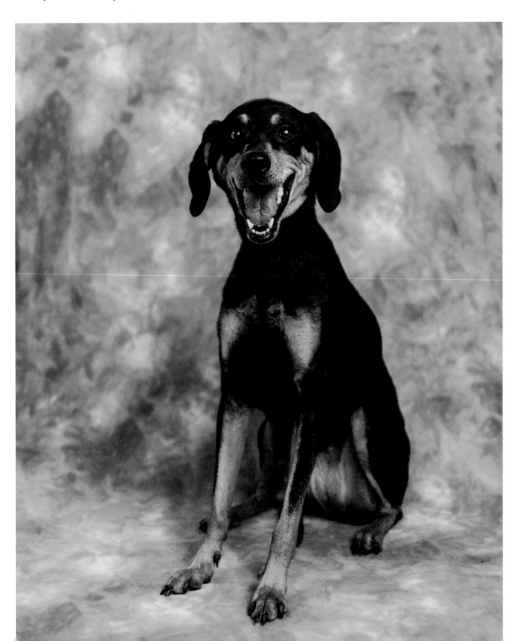

Lucy

(below) Lucy, a nine-year-old Basset Hound, arrived in rescue bonded with her sister, Lady. The pair were required to be adopted together. This can make getting adopted more difficult, especially when it comes to senior dogs. The two sisters were stood up several times and were once adopted and returned. Eventually, they found their forever home in February 2016 with a family that drove hours to adopt them.

Lady

(following page) Lady, an eleven-year-old Basset Hound, was bonded with her sister, Lucy, and they were required to be adopted together. Lady and Lucy eventually found their forever home after a few months in rescue. Sadly, Lady passed away about a month after she was adopted, but she was very loved in her final days.

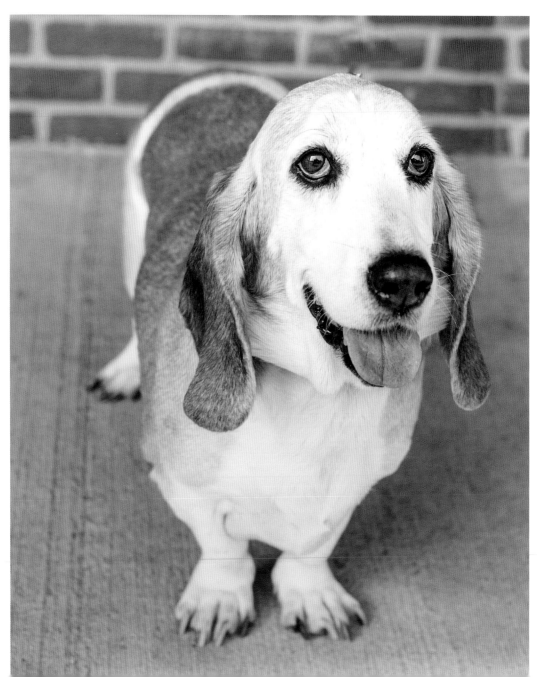

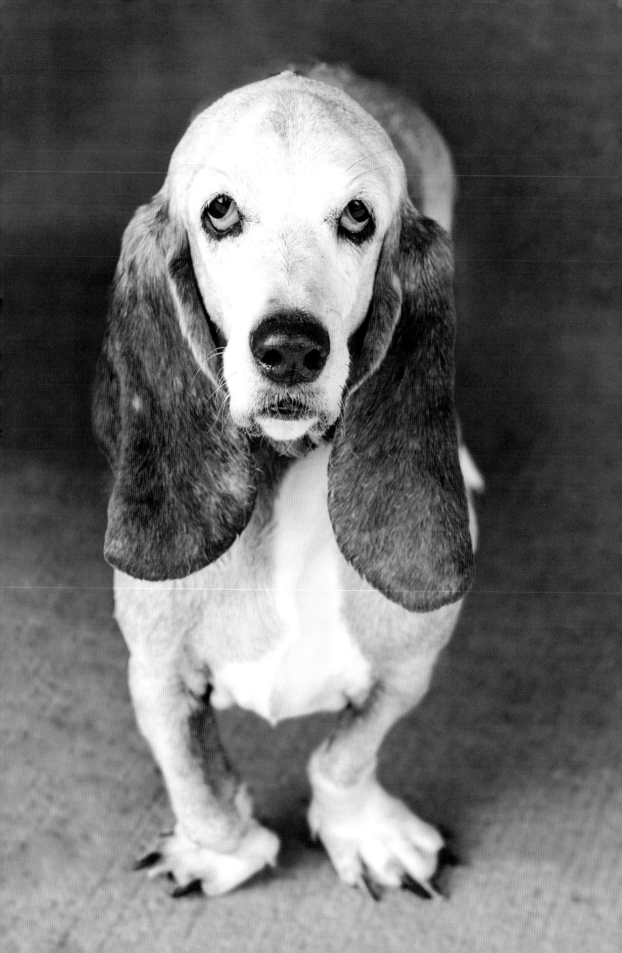

Sidney

(below) Sidney, a ten-year-old Golden Retriever mix, was rescued from a rural high-kill shelter. When she came into rescue, she was suffering from Lyme disease. Sidney spent several weeks in foster care receiving treatment and resting prior to being adopted in April 2016.

Big Boy

(following page) Big Boy, a very senior Labrador Retriever mix, came from a rural shelter looking for a better life in rescue. A laid-back dog, Big Boy loved nothing more than taking a nap or searching for a treat. Big Boy spent six months in his foster home before he peacefully passed away in July 2016.

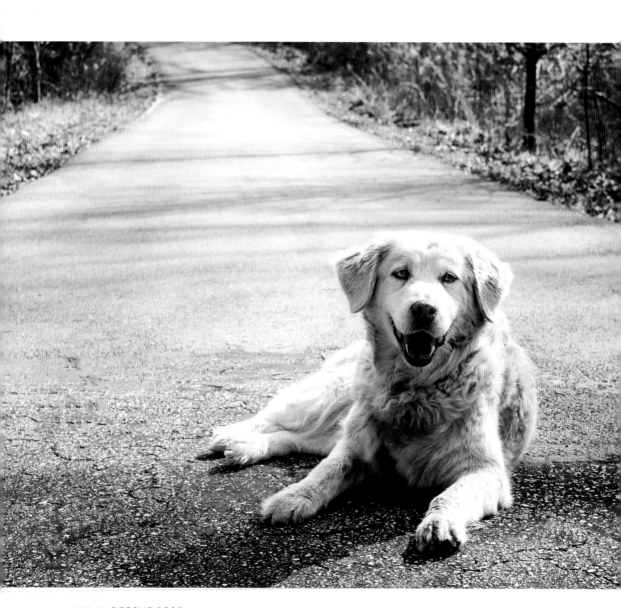

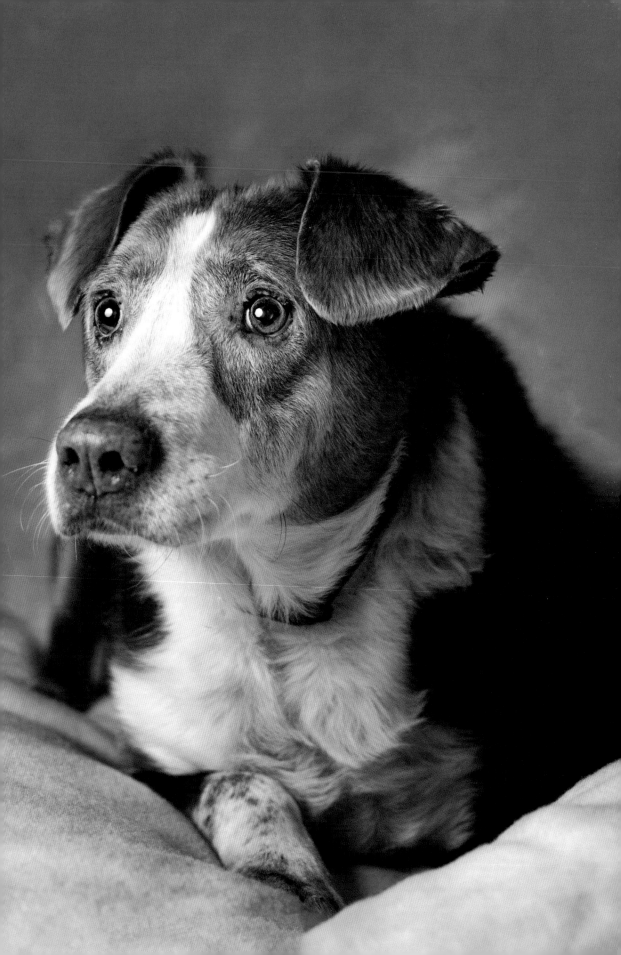

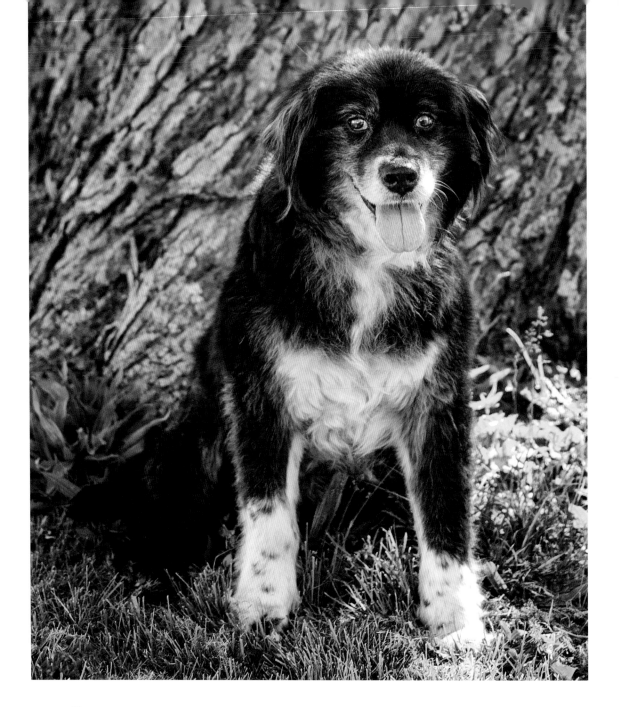

Bongo

Bongo, an eleven-year-old Australian Shepherd and Newfoundland mix, spent his life chained up outdoors and neglected. When he wound up in rescue, his coat was severely matted and dirty, and he was in generally poor shape. This low-energy senior guy loves napping and the occasional walk. He found his forever home in May 2016.

SPECIAL NEEDS

Abraham

Abraham, a two-year-old Shih Tzu mix, came to rescue from a shelter in Kentucky. He had a bad eye, which had to be removed. He was adopted in February 2017.

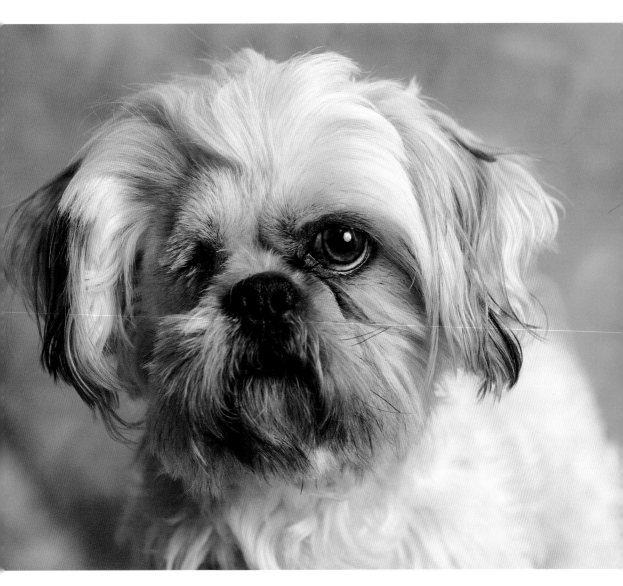

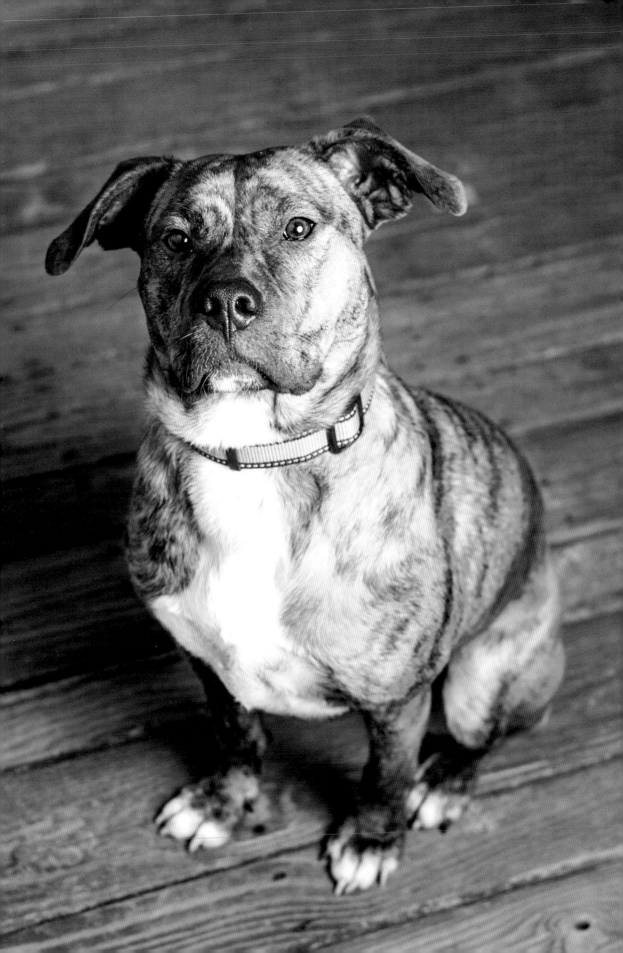

Katie

(previous page) Katie, an eleven-month-old Boxer and Treeing Cur mix, has only three legs, but you would never know it from the way she gets around. She came to rescue from a rural shelter where dogs with disabilities don't stand a chance of getting adopted. Her new family absolutely adores her, and she is very happy in her loving forever home. They kept the name Katie because they said it suited her. With her winning personality, Katie has even gotten her ten-year-old rescue dog brother to play with her. Her adoptive mom says that she is very verbal and almost talks when she wants something. She plans to do a doggy DNA test to find out what Katie really is!

Princess Sophia of Clermont

(below) Princess Sophia of Clermont, a very fancy name for this senior Poodle mix, arrived in rescue from a shelter weighing in under seven pounds. She spent time getting into shape, growing her hair, and gaining some weight so that she could find her forever family. She went to a foster-to-adopt program in February 2017.

66 She came to rescue from a rural shelter where dogs with disabilities don't stand a chance . . . 99

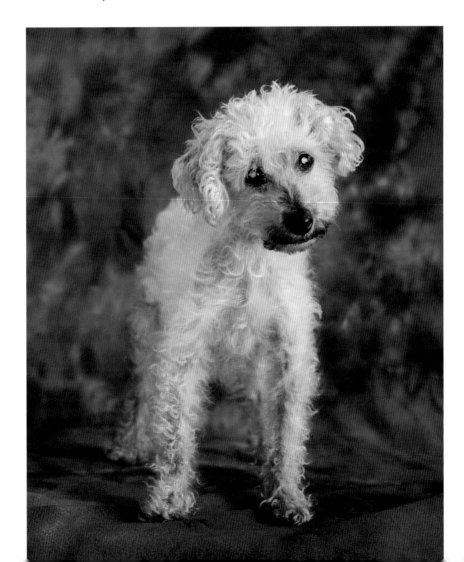

Rocky

Rocky, a six-year-old Labrador Retriever, Hound, and Boxer mix, spent a life in rural West Virginia chained up before ending up in a high-kill shelter. He was brought into rescue after someone stepped up to foster him. It was discovered that Rocky had eye problems, which are believed to have been caused by head trauma he suffered in his early life. Rocky, though completely blind in one eye and partially blind in the other (due to a detached and semi-detached retina), managed quite well in his foster home and was able to get around quite well, even on steps.

Rocky spent over seven months in his foster home seeing other dogs with the rescue come and go, but no one applied to adopt him. Rocky's foster family loved him so much, and he did so well in their home, that they eventually decided to adopt him in November 2016. Rocky now lives a life of leisure, napping on the couch and enjoying treats from his very loving family.

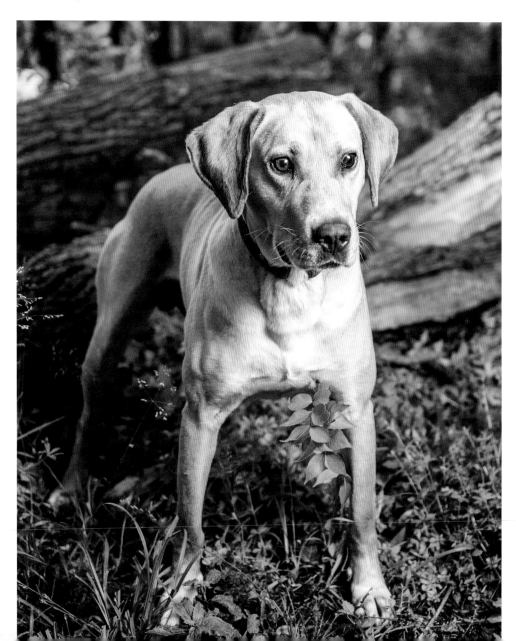

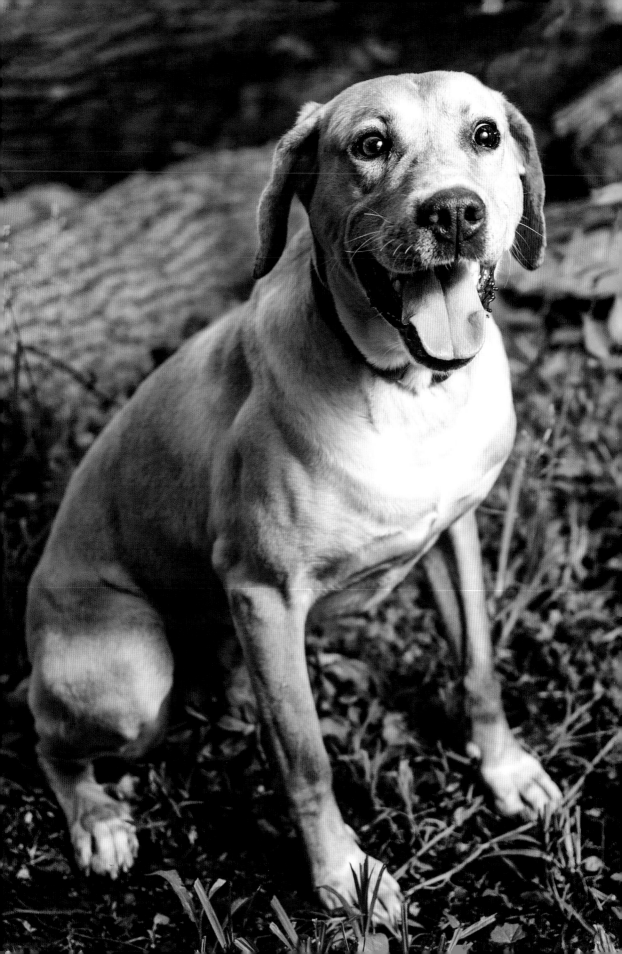

Momo

(below) Momo, a ten-year-old, was rescued from a high-kill shelter in West Virginia. He was adopted by his foster family after they fell in love with him. His new owner says their vet believes Momo to be a Labrador Retriever and Hound mix, possibly a Treeing Walker Coonhound based on his features and coloring. Despite the fact that Momo is blind, he navigates his new home very well and gets along with his four cat siblings.

Bailey

(following page) Bailey, an eleven-year-old blind Miniature Schnauzer, was brought into rescue when a young girl stepped up to save him. Senior dogs and dogs with disabilities usually don't stand a chance in shelters, let alone senior dogs with disabilities! If it weren't for his young foster, Bailey wouldn't have had the chance to find his forever family. Bailey's story was featured on the local news, which helped in getting him adopted quickly. He found his forever home in February 2016.

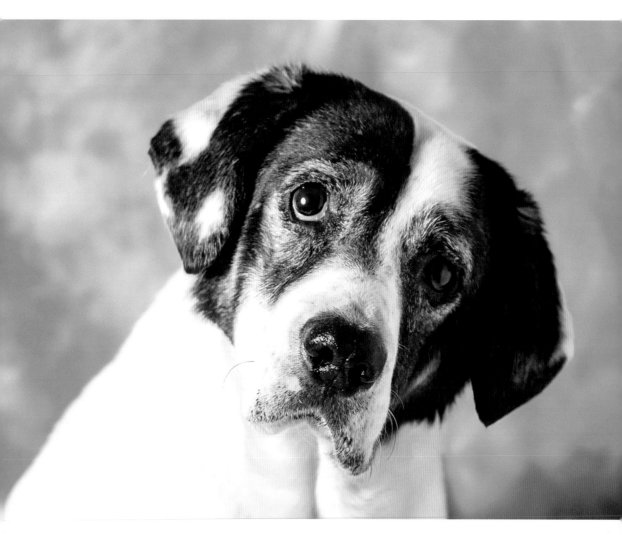

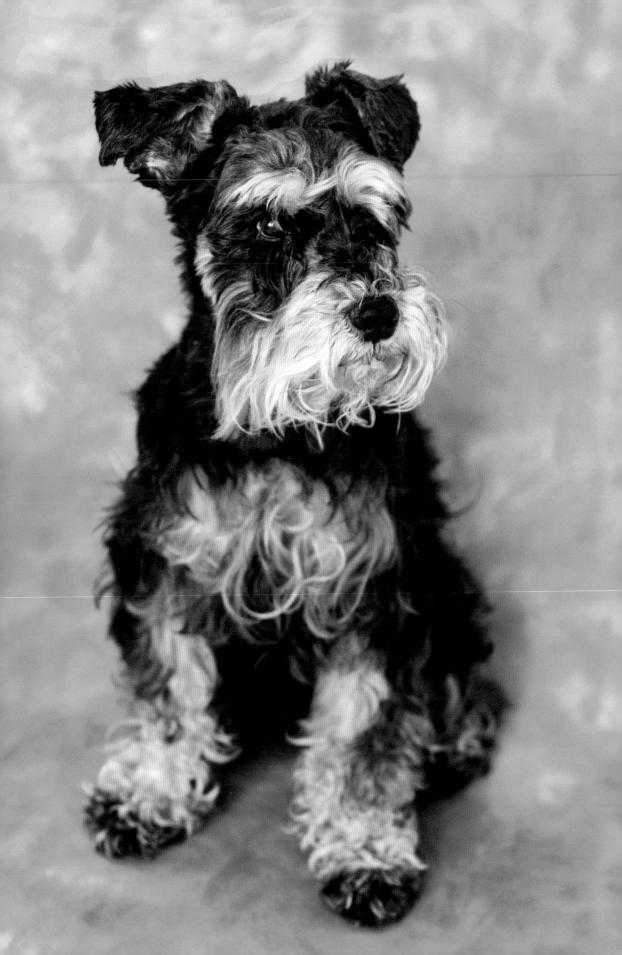

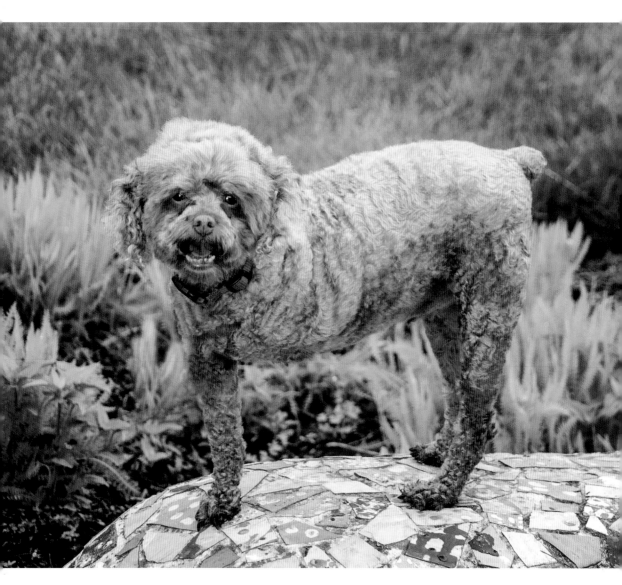

Buddy

Buddy, a six-year-old Toy Poodle and Shih Tzu mix, was trampled by a big dog when he was a puppy and lost a front left leg as a result. However, he doesn't let that get him down or prevent him from being a happy, friendly guy. He was adopted in New York City in May 2016.

GROUPS ⑤

Astro and Daisy

Five-month-old Astro and his big sister Daisy are both German Shepherds. At the age of six weeks, Astro was "donated" to a shelter by a breeder. His new adopter was excited to have him join her family, but she had to wait until Astro was eight weeks old to adopt him. This sweet dog is a great companion and follows his new mom everywhere. German Shepherds are known to be highly intelligent and loyal dogs, and Astro is shaping up to be no exception.

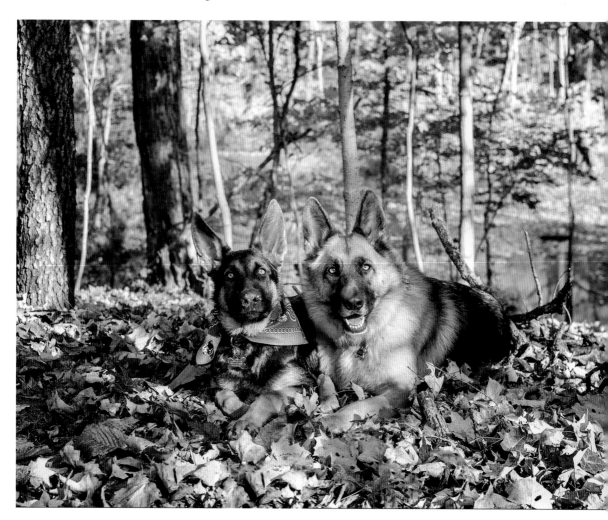

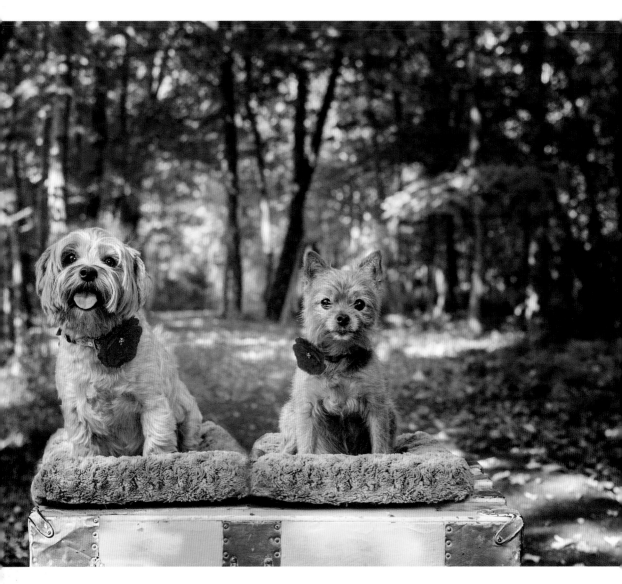

Sophie and Tinker

Sophie, a five-year-old Yorkshire Terrier, was born into rescue in 2011 when her mother was dumped by a breeder. The rescue discovered mom was pregnant when they took her for her spay and allowed her pregnancy to come to term; thus, Sophie was born. Her adoptive family fell in love with her at first sight.

Tinker, also a Yorkshire Terrier, now twelve years old, was rescued by her forever family at six weeks old from a backyard breeder. Both Sophie and Tinker are spoiled, as they should be, and very loved in their forever home.

66 Sophie, a five-year-old Yorkshire Terrier, was born into rescue in 2011. . . 99

Gizmo and Teddy

Gizmo, and his younger brother, Teddy, are both Spaniel mixes. They are totally unrelated other than through adoption. They are both friendly and playful rescue dogs. Their parents treat them like royalty and were inspired to start a natural dog treat company, because they know the importance of feeding our pets quality foods made with good, natural ingredients.

66 Their parents treat them like royalty and were inspired to start a natural dog treat company... 99

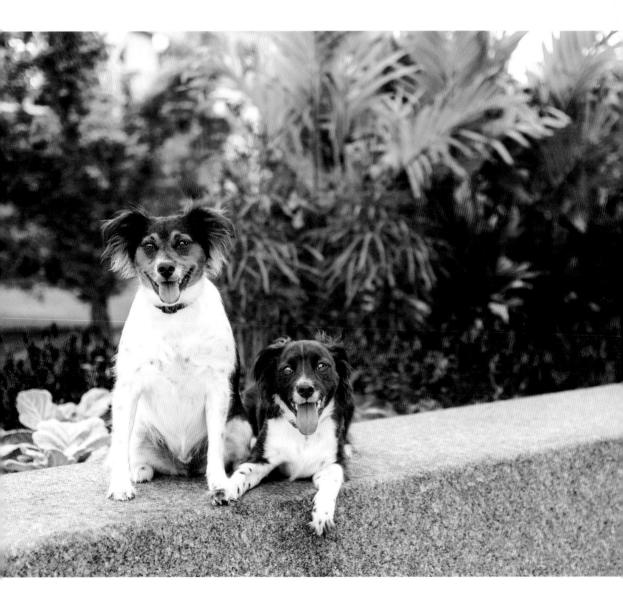

Annie, Mowgli, Sasha and Herschel

Annie, Mowgli, Sasha, and Herschel are all rescue dogs in the same family, adopted at different times. Annie and Mowgli are Hound mixes. Sasha is a German Shepherd and Siberian Husky mix. Herschel, the youngest, is an American Bulldog mix. They are all very friendly and happy dogs that are part of a loving family, which also includes several cats.

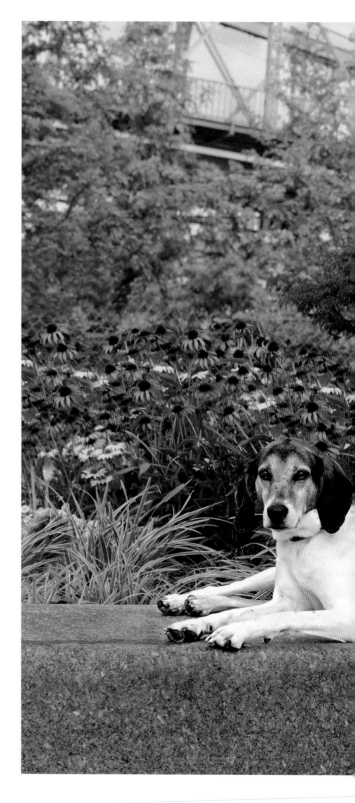

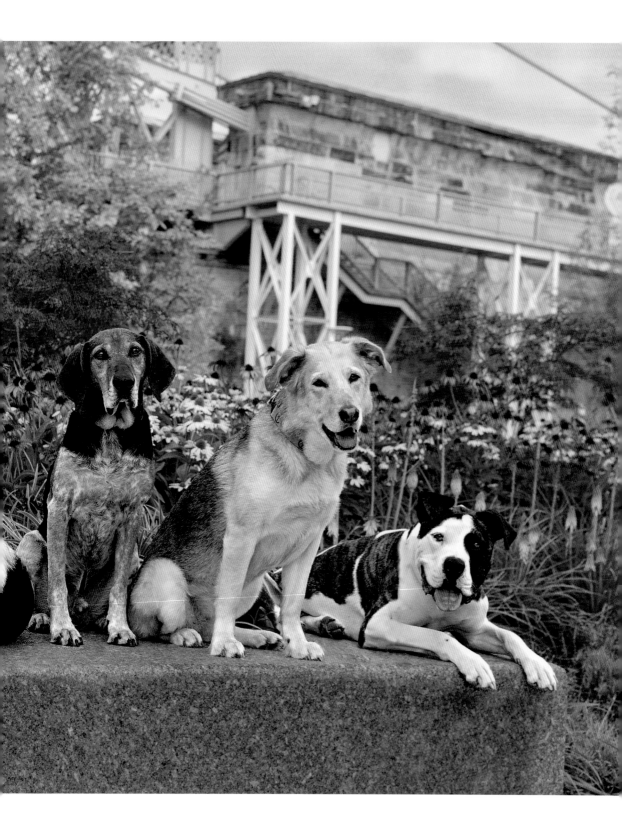

INDEX